D0507801

An Odyssey in Steam

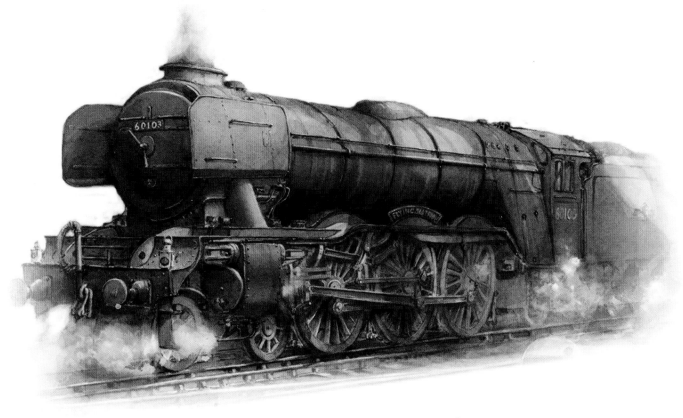

Written and illustrated by

DAVID C. BELL

This book is dedicated to four young
enthusiasts of steam — my grandsons
Kyle, Oliver, Rupert and Monty.

An Odyssey in

STEAM

Railway Paintings

from

'Rocket' to 'Evening Star'

Written and illustrated by

DAVID C. BELL

Quiller

Copyright © 2017 David C Bell

First published in the UK in 2017
by Quiller, an imprint of Quiller Publishing Ltd

British Library Cataloguing-in-Publication Data
A catalogue record for this book is available
from the British Library

ISBN: 978-84689-252-3

The right of David C Bell to be identified as the
author of this work has been asserted in accordance
with the Copyright, Design and Patent Act 1988

All rights reserved. No part of this book may
be reproduced or transmitted in any form or
by any means, electronic or mechanical including
photocopying, recording or by any information
storage and retrieval system, without
permission from the Publisher in writing.

Printed in Malaysia

Quiller
An imprint of Quiller Publishing Ltd
Wykey House, Wykey, Shrewsbury, SY4 1JA
Tel: 01939 261616 Fax: 01939 261606

E-mail: info@quillerbooks.com
Website: www.quillerpublishing.com

Contents

Foreword

I first met David professionally some 10+ years ago on the hunt for products for a maritime-themed mail order catalogue.

We bought some greetings cards David had produced featuring some of his maritime watercolours and following their success moved on to sell his prints, which continues today. Over that time we have met infrequently, a few times a year, but never has that time been anything other than fascinating ...

David's passion for a subject is insatiable ... His memory for both facts and figures, intricate detail and a good story are what drives his passion for painting.

At that time all I knew of David was his maritime art, and world renowned he was too having painted many subjects from HMS *Victory* and Trafalgar through to fishing trawlers and cargo ships, coastlines and harbours. David has published four books featuring his maritime work and has work in the Royal Collection. So, it was a revelation when only more recently I discovered that maritime subjects weren't David's only love ... in fact some of his earliest memories as a young boy, and a passion still burning today, was for the world of steam and the locomotives, sheds, stations and the sheer detail that has smitten many a young boy, me included, and stayed with them a lifetime.

This book is a real personal journey for David from his earliest boyhood memories in his local engine shed in Doncaster transfixed by the giant locomotives towering above him... to now travelling the country sketching and painting as many of our preserved locomotives as possible, and often putting them back into a historically accurate setting, recreating evocative scenes of a bygone age.

Steam was withdrawn from British Railways in August 1968, however as I write this the first commercial steam-drawn train in nearly fifty years has just completed a three-day stint on the beautiful Settle–Carlisle railway. The modern-built *Tornado* hauling the regular Appleby to Skipton service, much to the delight of enthusiasts and the wonderment of the regular commuters on the line. Perhaps after nearly fifty years we will see more regular steam-hauled services, it somehow only feels right!

At one point in the book David says, 'I have a passion for steam engines far more than my actual knowledge', which when you meet the man and hear him enthuse and go into intrinsic detail about a 'double blastpipe', or the complexities of 'smoke-deflectors', leads you to quickly dismiss his comment. David is one of those aficionados who has no idea of the breadth and depth of his own knowledge. Like his painting, the intricate detail is astonishing and whether it's steam locomotives, ships or aircraft, their very being seems to ooze from David in his painting. One of my favourite images is actually a sketch, rather than a watercolour, and set in a 'Shed' scene. See page 72 and tell me you can't hear the noise, feel the heat, smell the fumes and feel like you are there, watching that mighty loco being turned ready for it's next day's work ... tremendous.

I knew David was a great maritime artist, and now to me, this book brings his skills in portraying the world of steam railways into the 'great' category as well. He promises more to come at various points in the book, I can't wait. I'm sure you will agree.

Ross Morrell
January 2017

Introduction

Steam engines were on the scene in the Cornish tin mines as early as 1689, and their use and development spread rapidly to other parts of the country. The great Scottish engineer James Watt was the man to develop and utilise the power of steam for the transport scene.

As I mention later in the book in reference to the humble W and P Railway and its development in the 1830s from the horse-drawn carts on parallel wooden rails to later steam traction on iron rails, this method had already been used in sixteenth century Germany, also on wooden rails. However, it was in the 1820s that a method of producing wrought iron rails was developed by Englishman John Birkenshaw that set the standard of a permanent iron track.

The cornishman Richard Trevithick designed and built the first steam locomotive in 1804. Later, in 1812, John Blenkinsop and Matthew Murray built the 'The Salamanca' (4-foot gauge), although the first passenger-carrying public service was the Oystermouth Railway in 1807. In 1813, engineer William Hedley and blacksmith Tim Hackworth designed and built the famous Puffing Billy for the tramway between Stockton and Darlington. Then on the scene came George Stephenson and his first steam design, the Blucher. He was then appointed as the engineer for the Stockton to Darlington Railway, all 25 miles of it, and with his improved Locomotion No1 it became the 'first' steam-hauled railway in the world.

That was in September 1825 and many, many more railway companies were formed, creating a network of small railways until most places, big and small, were connected by rail.

In the Railways Act of 1921, most of the existing rail companies were 'grouped', by area into four companies: the LMS, LNER, SR and the GWR. One significant railway, the Midland & Great Northern Joint Railway, was not grouped.

The grouping of the big four was a means of improving and standardising the railways on equal term, but the rivalry between the companies was still intense from 1923 to nationalisation in 1948. In particular, the competition between the LMS and LNER, the two east and west coast mainlines from London to Scotland, was most intense. The desire to achieve the fastest and most comfortable journey north–south produced the great engines we know today. The Chief Mechanical Engineer of the LMS, Sir William Stanier, and LNER's Sir Nigel Gresley, creators of the great 'Pacific' engines, forms the backbone of this book.

It cannot be understated what effect the two wars of the twentieth century had on the railways. After the Great War the automobile was born on a mass scale of immediate personal transport, both private and commercial, and the construction of highways started — and is still going strong today!

The 'common carrier' requirement by law was made to have freight, and the public, transported at an equal cost by the railways and not necessarily profitable. This awkward and undesirable method continued until 1957.

Between the wars the actual profits made by the rail companies was still small or even negligible as the car industry boomed and rail freight was in competition with road transport. Even so, the rail companies invested heavily throughout, and during the Second World War they united into one and the railways blossomed again into a vital force to help with the war effort.

It was post-war that the railways went from the dark, dirty and unknown days to the nationalisation programme and British Railways — and the era of, eventually, Standard BR green for all express engines. The second nail in steam's

boiler was the modernisation scheme of the mid-1950s, or the famous 'Beeching plan', or axe, as it became known. More than a third of railway lines, mainly minor rural lines disappeared, along with much stock.

The third and final nail was, of course, 'dieselisation' from the mid to late Fifties and the withdrawal of all steam engines by the mid-1960s.

The end of steam-hauled trains on British Railways was on 12 August 1968. It was called the 'Fifteen Guinea Special' and was a special railtour from Liverpool to Carlisle and back, hauled by four engines — LMS Class 5 45110, then Britannia Class *Oliver Cromwell 70013*, then LMS Stanier Class engines *44781* and *44871*. The steam ban was then introduced the following day — apart from a final journey by *Oliver Cromwell 70013*, which went back to Norwich for preservation.

All these engines are now preserved, apart from *Black Five 44781* which sadly did not escape the cutter's torch.

There was a strange exception in the *Flying Scotsman*, which was purchased by Alan Pegler in 1963 and allowed to run on the mainline, but most observers saw the 'Fifteen Guinea Special' as a final farewell to steam on our national railways. But only three years later 'special railtours' had been introduced, with the first hauled by GWR *King George V 6000* in 1971.

All steam engines I admire but I do have my favourites. I was brought up in the midst of the LNER and especially with the steam and sounds of Doncaster Shed and the 'Plant'. I am naturally drawn to them, if you will excuse the pun, and they dominate my memories when creating a picture.

You could, I believe, whether artist or historian, produce a worthy book on every single class of engine built in the twentieth century. Not a task I would want to undertake and pursue but I have and will endeavour to paint every engine I see and admire, and hopefully for the next publication.

An Odyssey in Steam is, entirely of my own making, including contents, illustrations, text and design. This first collection has been a considerable task in finding and preparing all for publishing. I hope the accompanying text is relevant and accurate for all its readers, young and not so young.

Since I first inhaled the smoke and steam from the spouting chimney of a 'dubbie', on the footbridge at Habrough station on the Grimsby to Doncaster line in the Fifties, I've had a love affair with the steam engine. How I didn't become an engine driver or at least an engineer I'll never know to this day.

My veneration for steam engines is provoked, like everyone's, by these immense creations of iron and steel that just exude a unique mixture of steam, smoke, smell noise and usually plenty of grime.

I do accept that the book is itself dominated by my 'own' region, the LNER, with its engines and sheds. I'm sure the opposite will be true in volume two.

I hope this small journey in art brought about by my relatively few years involved in steam will be enjoyed by all.

David C. Bell
Dunston
Lincoln 2017

Chapter One

The 'National Railway Museum'
& its locomotives

What a place to start. A varied, intense and fully established museum of great interest to everyone who walks through the main doors on Leeman Road. To me, as to many, it's become a place of pilgrimage. The permanent array of steam and diesel engines in a clean but real environment, always seems to fill your senses with, well it has to be said, the steamy images of yesteryear.

Since I first visited the museum around 1972 it has greatly expanded in size and its collection of resident engines — and, of course, all the railway ephemera that goes with it. The pencil drawing of *Mallard* on page sixteen has been stored since that time and was still in the drawer, but it has been included as a little bit of nostalgia for myself. I had the simplest task of just sitting down leaning against a wall sketching with hardly anyone about at that time, except the many 'admirers and critics' of very large school trips!

In the museum's collection, perhaps not quite the first locomotive built, but not far off, is the replica of Stephenson's 1829 *Rocket* which I have illustrated here on page twelve. The original built in 1829, is now for the most part exhibited in the Science museum. Even there it is quite a spectacle.

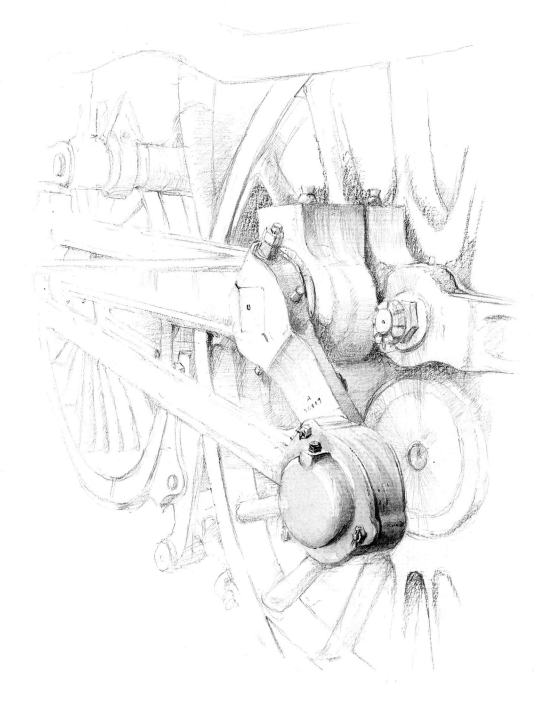

This is a view from the driver's side of the **Flying Scotsman** of the main driving wheel and rods when on show in the Main Hall at York.

The drawing on the next page was a rather ambitious drawing with, initially, the main focus on the signal gantry, but then including in the foreground the locomotive and the strange 'horse and carriage' and finally giving up with the impossible-to-render complex structure of the roof. The 'double signal' drawing is from the warehouse next door.

The 'Great Hall'...

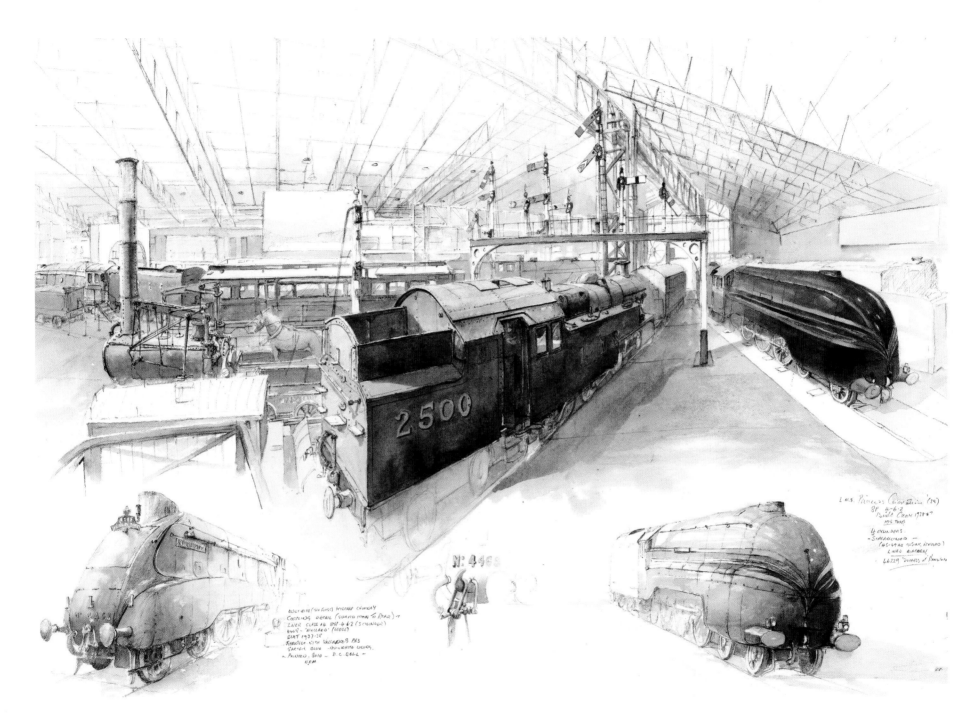

This panorama was drawn from the footbridge in the Great Hall around 2007, I think, as there is no date on the picture. It's all on one sheet of paper with the LMS Stanier Class 4P 2-6-2 No 2500 (BR 4MT) tank engine as the main subject. Designed specifically for the London Tilbury and Southend line, it is unusually a 3-cylinder engine, apparently to give it an extra kick when on those frequent passenger duties. Of the thirty-seven built in Derby in 1934, this is the only survivor, withdrawn in 1961, and now in the NRM collection. I believe it is now totally restored and based at Shildon.

... at the NRM

The 'Rocket'

In 1934 a replica was built by the same Stephenson's of Newcastle for Ford in the USA. On its centenary another replica was built by Locomotion Ltd, which is now at the York museum. This drawing is based on the superb reproduction of the original static model in the Main Hall.

Another working replica, with some modern safety improvements, was built in 1979, for the 'Rocket 150' celebrations and held at Rainhill in 1980 to celebrate the opening of the 150th anniversary of the 'Liverpool and Manchester' railway.

Debatably, perhaps, I'm beginning with the first real steam engine, the GNR 4-2-2 *No 1*, built in 1870. This engine, shown opposite, is a Victorian masterpiece. The big 'single' driving wheel was eight feet in diameter and starting off was no easy matter. With the basic engineering at that time the power of the piston turned the wheels far slower than in later years, but a large wheel covered a greater distance in relationship to the piston and coupling rod. As pistons, coupling rods and boilers quickly improved with developments in engineering, the wheel diameters came down to six feet eight inches but revolved more rapidly.

The 4-4-2 *Henry Oakley* No 990 of 1898 was the big breakthrough, and made all previous engines obsolete. The No1 *Stirling* is illustrated but unfortunately I do not have the scans of the *Henry Oakley* at this time.

These drawings on this and the opposite page are of two of the oldest static engines in the Main Hall while those that follow involve a big jump of fifty years.

The 'Stirling'

GNR 4-2-2 No 1. Built in 1870, this engine illustrates the classic single wheel, all eight feet of it. The engine is superbly preserved and on show in a prime spot at York.

It was last in steam only thirty years ago on both the Great Central and North Yorkshire Railways.

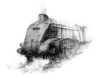

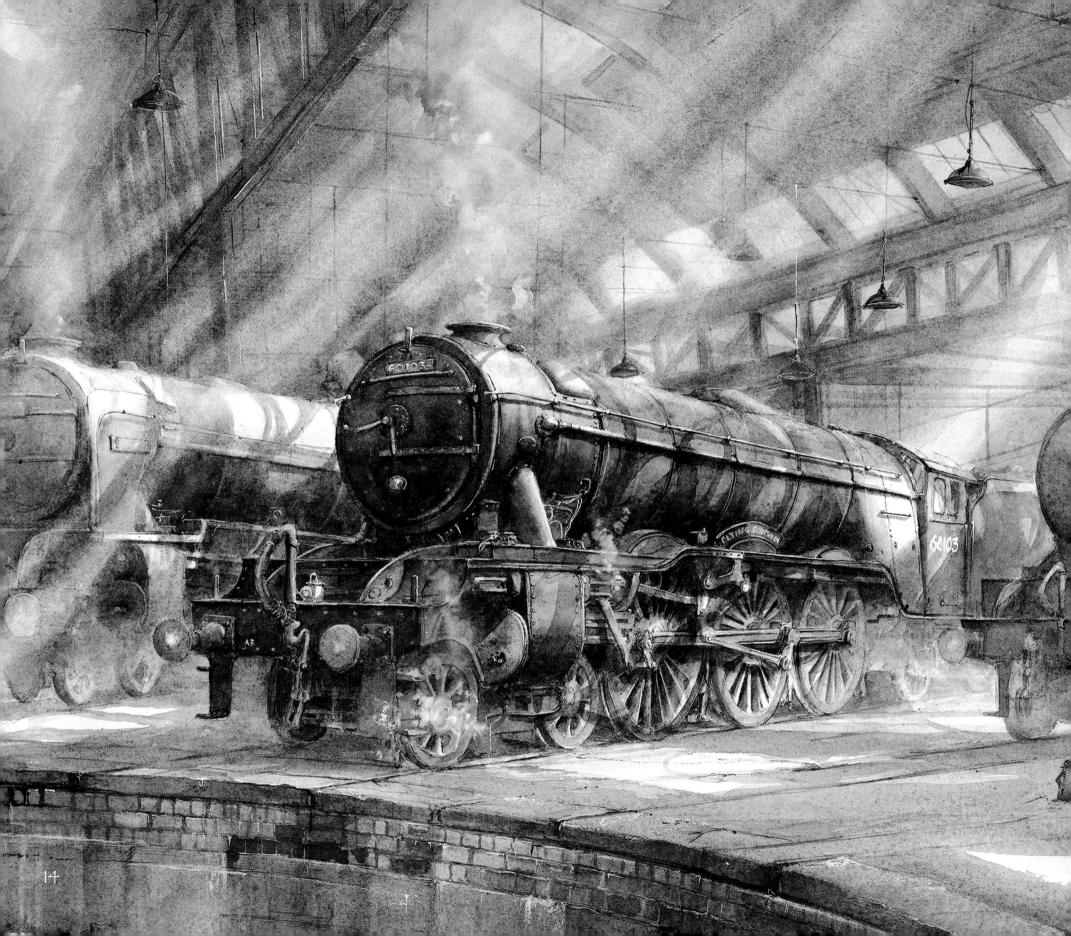

The 'Flying Scotsman'

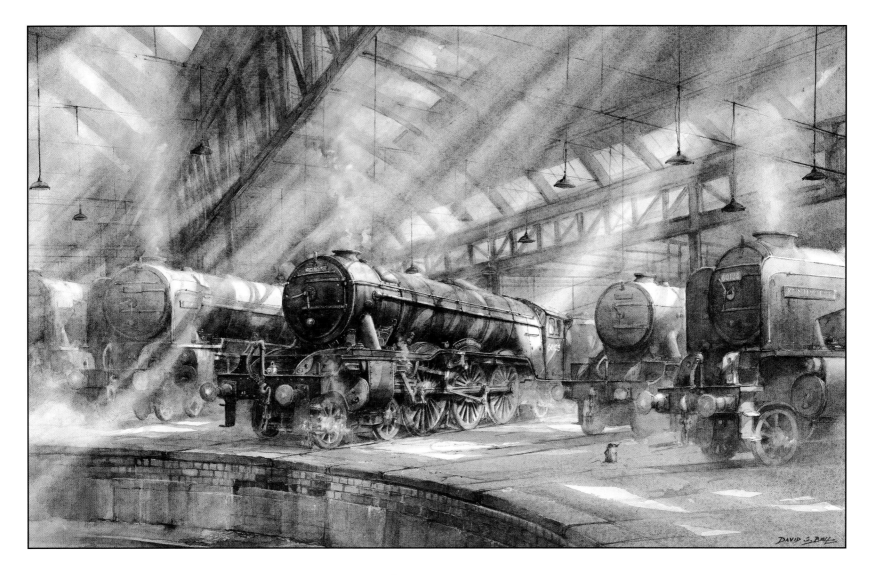

'Flying Scotsman'

A3 60103 at York Motive Power Depot 1953

The 'gatherings' at ...

The NRM with the 'Gathering' in 2013 had, of course, the vision and ability to make this exhibition happen and get together a rare if not unique collection of engines. The line-up of engines at York and Shildon was simply awesome. The two American visitors, 60008 and 60010, and the logistics involved, turned a special event into a once in a lifetime spectacle.

The painting 'Six of the Best' was actually contrived and portrayed quite some time before the event at York, which I visited subsequently along with what looked like half the population of the U.K. I couldn't see myself working out the problems of a line-up of six engines around a turntable so I decided that six engines in parallel, simply portrayed, in a fairly atmospheric scene would represent the event. Creating a painting at my studio easel was much more feasible than battling the crowds and weather.

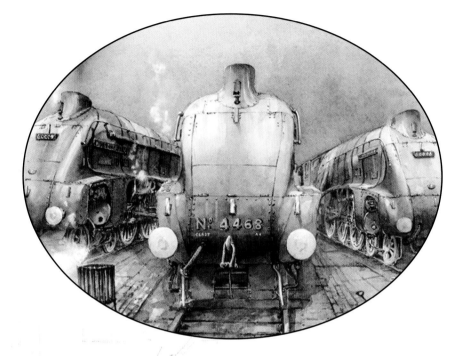

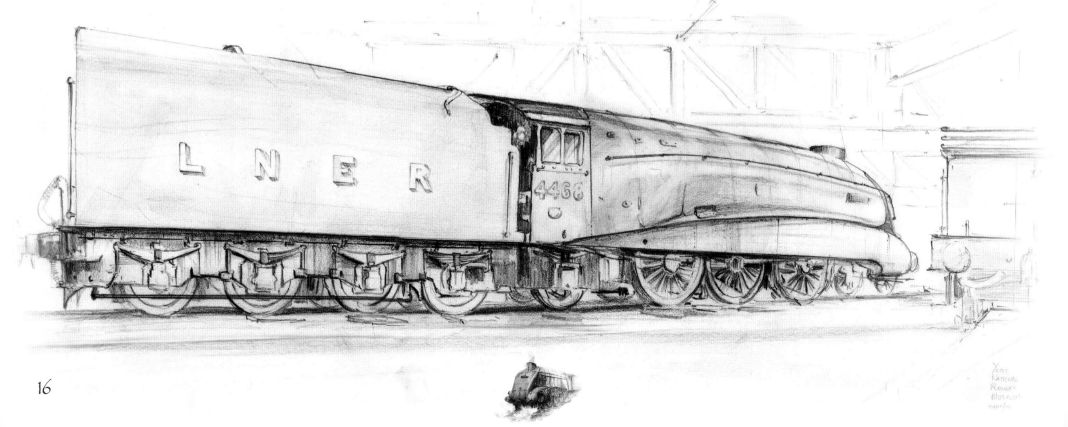

'York and Shildon'

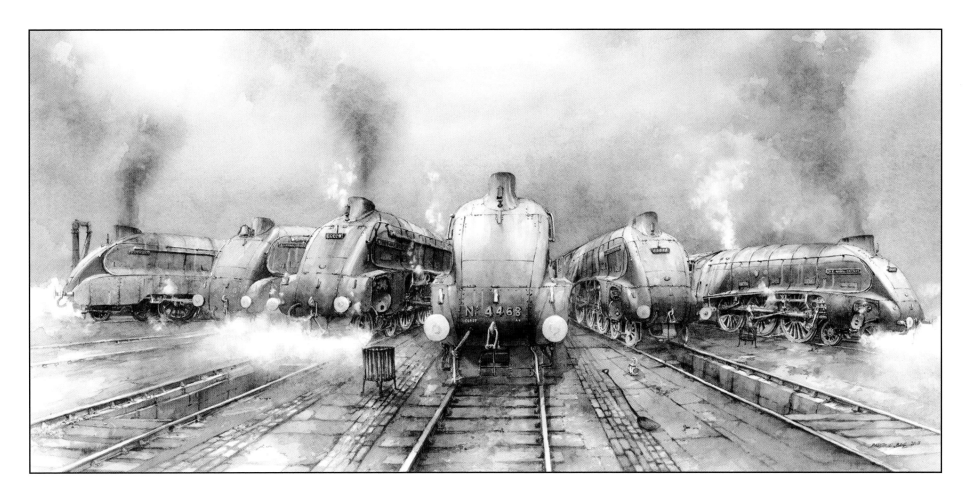

'Six of the Best'

The six A4s that gathered at York 2013

This was a large watercolour, intensely detailed, and in my view was a fair portrayal of the six A4s. All the engines were easily researched to show in what condition they would be displayed and I haven't had any complaints as to accuracy, as yet. Afterall, as I keep saying, it is only my interpretation of the event in this two-dimensional format. The brazier, lamp, shovel and the pits themselves are all included to complete the painting.

Though lacking in its organisation as a result of the unexpected visitor numbers, the Shildon show in 2014 was a little better. Providing a much more natural setting, it was so much more realistic in its line-up and the bonus of three engines in steam was quite magical.

The inclusion of the two American based A4s, 60008 *Dwight D. Eisenhower* and 60010 *Dominion of Canada,* made these very rare, once in a lifetime events.

What came over quite strikingly was the engine with the 'valances', or without? No point in covering up the best bits so my aesthetic vote would be without. Looking back at the two shows, Shildon provided a better environment from which to produce a painting.

Both scenes had tremendous atmosphere and were very successful as paintings themselves. Of course, a very special thank you from all of us enthusiasts should go to Steve Davis, at the time, director of the NRM, for his vision.

Not included here but hopefully in my next book I will have a very much deserved chapter on the 'magnificent six', with special attention to *Mallard*.

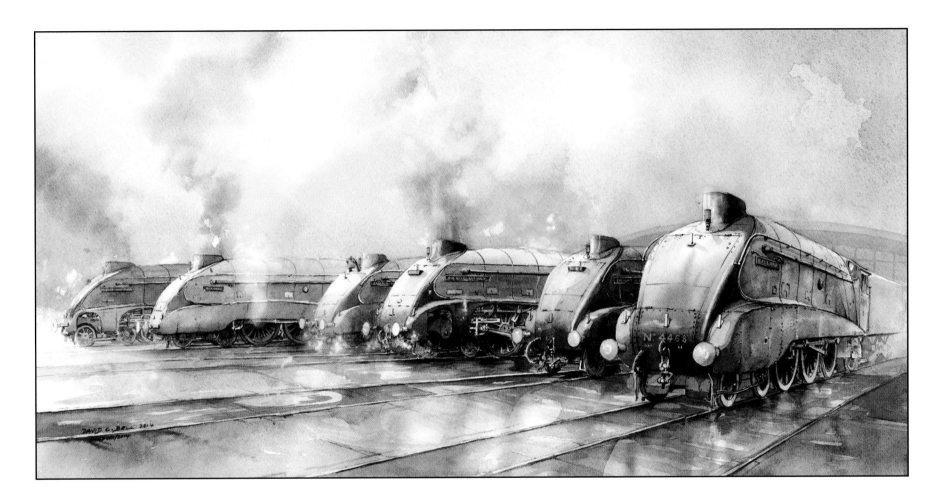

'The Shildon Six'

The six A4s that gathered at Shildon, February 2014

Mallard is on the far right and next is the **Union of South Africa** , also known as 'No 9'. The latter was not only the last A4 to receive a general repair at Doncaster but was also the last steam-hauled special train to leave King's Cross on the 'Requiem Special' on 24th October 1964, although this watercolour is from a much earlier scene. After withdrawal in 1966, and destined for preservation, the engine was also used to haul the last steam 'special' in the Scottish Region, sharing the journey with Class 5 No 44997.

The 'Evening Star'

My first encounters with the *Evening Star* engine, now in the NRM, was at a Didcot Open Day in the late Seventies, when you could get on it and take a short ride up and down the demonstration track. Looking at it today I see no difference at all — immaculate, hugely powerful and, more than anything, ready to go. I have a sketchbook full of images of this engine, some shown here, but it is one engine I cannot recall seeing in its working life. I did venture far with the railway club I had joined but do not recollect going to South Wales — as a boy Cardiff was a long way from my local Doncaster shed!

*My favourite engine at York when it's there, is **Evening Star**. It's a great engine to observe and draw the impressive and intricate mass of engineering.*

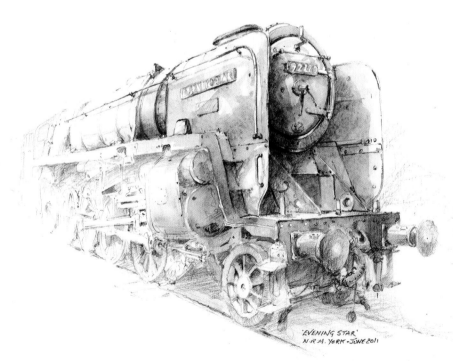

'EVENING STAR'
N.R.M. YORK - JUNE 2011

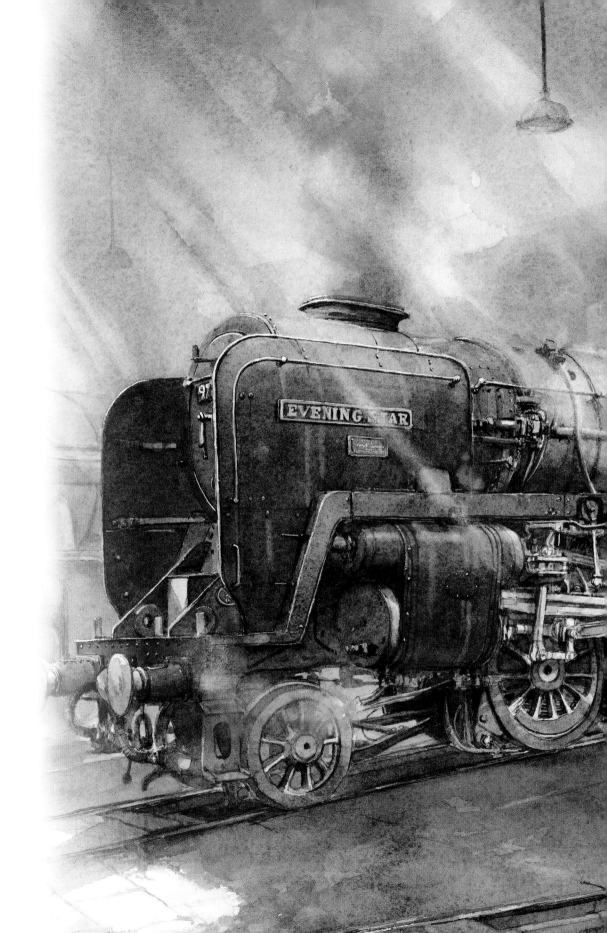

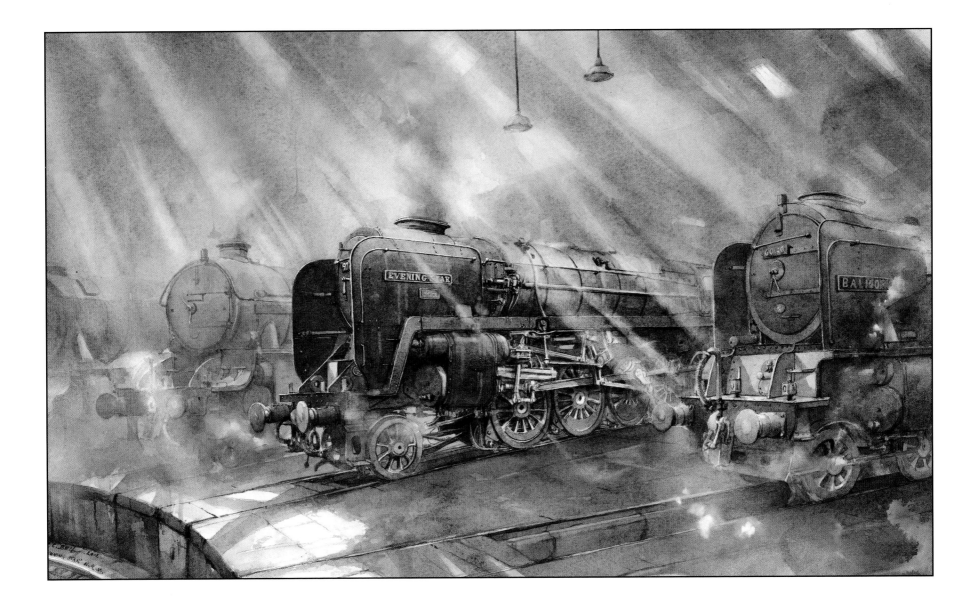

'Evening Star'

9F 92220 York NRM

The actual position of the engines around the turntable is how you would have seen 9Fs at York in their working life. Had it been in the early Sixties then this how it would possibly have looked alongside the shed's resident engines in this atmospheric scene. This is exactly the scene now, except I have brought it to 'life', as it were, back to the steam days, substituting a resident 9F with **Evening Star.** It is an imaginative painting as I have no evidence that the **Evening Star** actually visited York at all in its short working life.

The 'Great Hall' is the hub of the museum, built over the two original turntables with the tracks providing the 'base' or parking space for the rest of the static engines including diesels and carriages. The north turntable is still functional and does a 'turn' most days.

The museum's 'The Works' is a fascinating place to visit when a great engine is being dismantled beyond recognition. Having all been correctly numbered, eventually the pieces do go back together, given a few years.

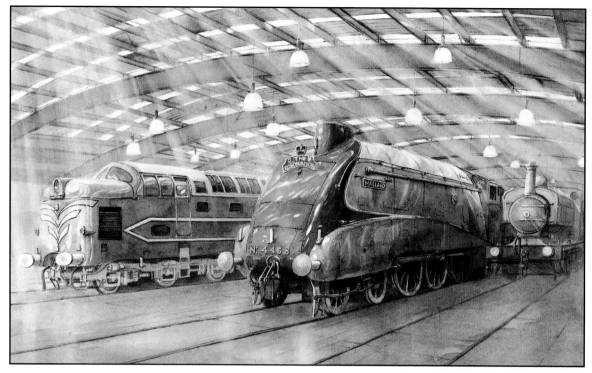

*This watercolour named 'Blue Icons' was painted after a chance visit to Shildon and me immediately being inspired to paint the 'prototype **Blue Deltic** and **Mallard** together as shown. I think this is the only painting in the book with a non-steam subject, hence it taking a much smaller spot.*

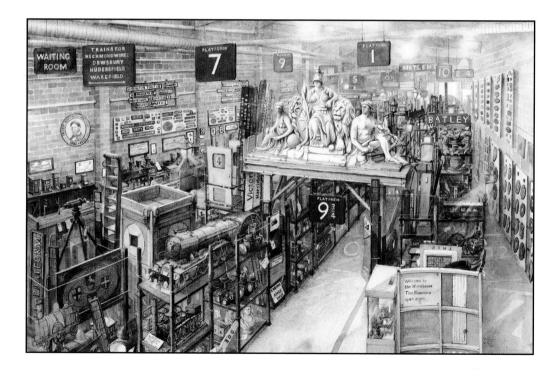

The access stairs at the back of the warehouse is the spot where I started my watercolour panoramic view of the collection. I had only wanted a drawing of the marble statue, which was nicely raised and easily studied, but somehow it developed into a 'labour of love' with many hours of work and endeavour. To what end I'm not sure. I simply felt each exhibit was too interesting to omit.

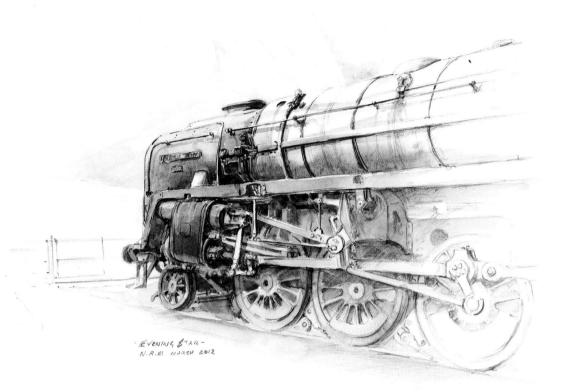

- EVENING STAR -
N.R.M MARCH 2012

Studies of Evening Star

Main Hall, NRM. On a rare event even on the turntable. The sketch below was painted on a blue/grey paper.

BR 2-10-0 Class 9F 92220 Evening Star

This engine was built at Swindon, 1960, as the last steam engine and was destined for preservation during its build. It's been here for a long time now and, being static, is a great subject to study and draw. These engines were, probably, the most successful of all the Standard Class designs. But the other 9Fs in general, all 250 of them, were a ubiquitous bunch, and a great favourite of mine.

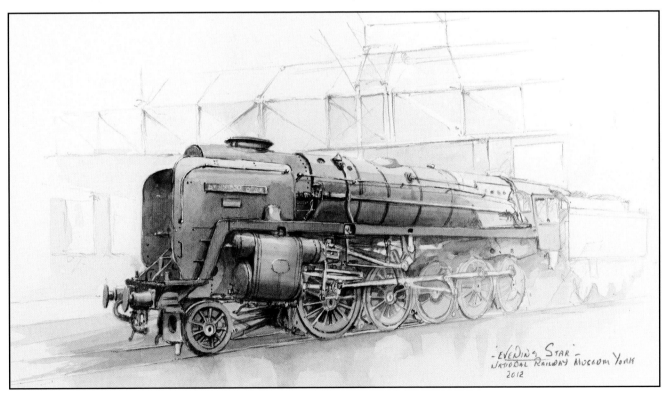

- EVENING STAR -
NATIONAL RAILWAY MUSEUM YORK
2012

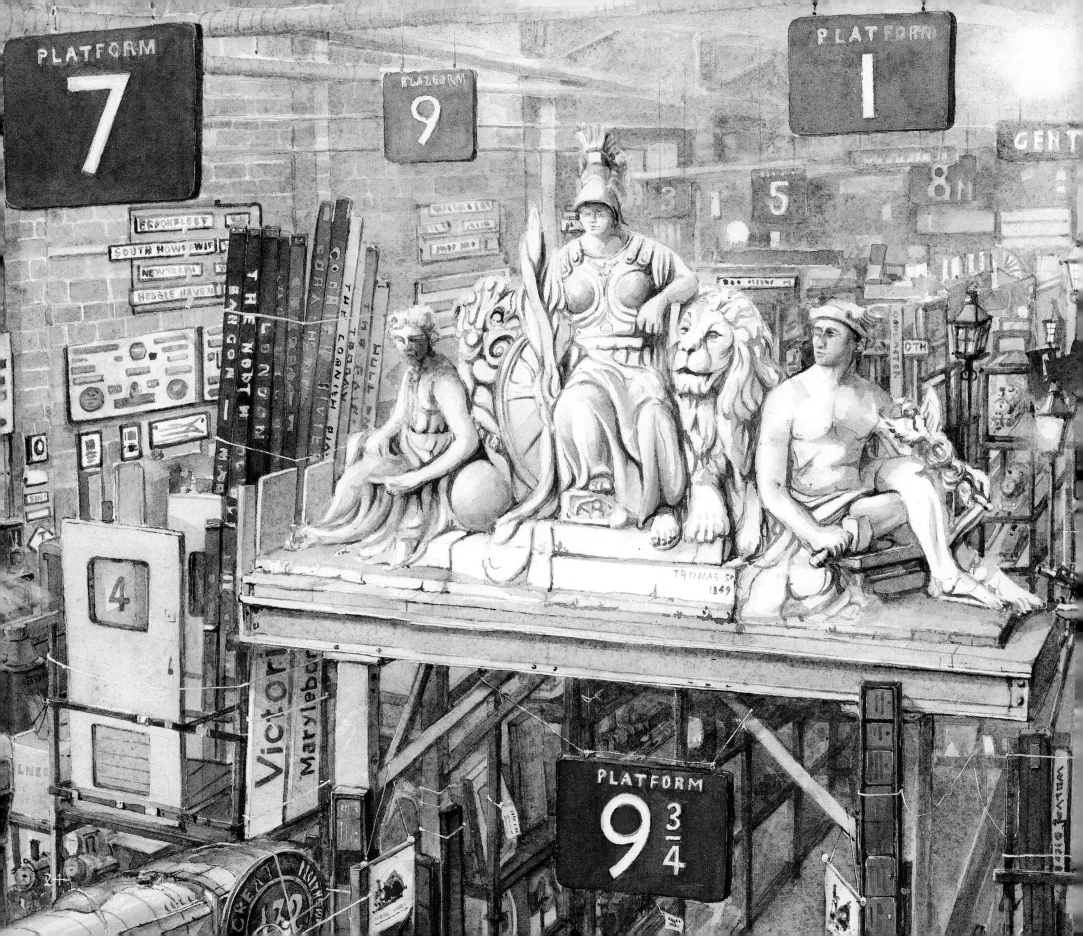

The 'Warehouse'

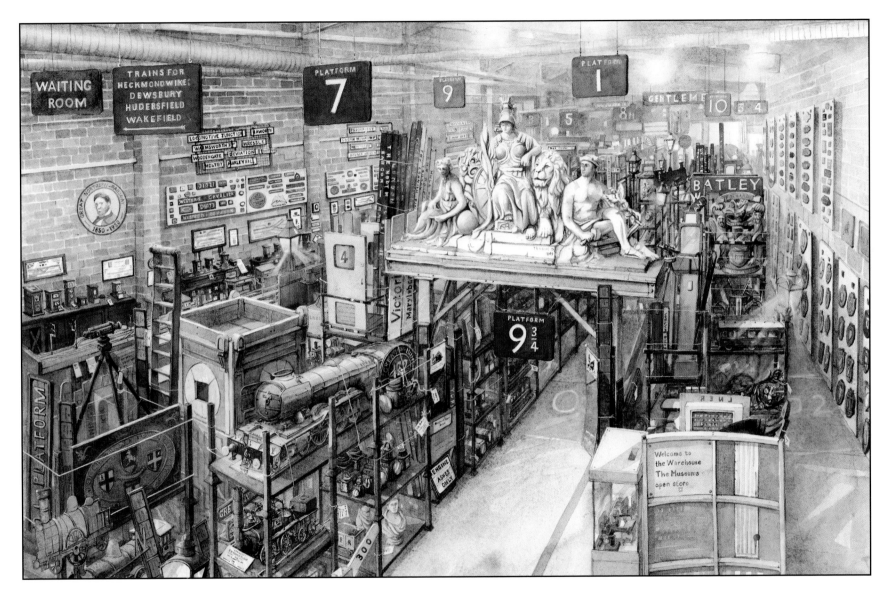

The 'Warehouse'

As the sign in the foreground says it's the NRM at York's 'Open Store'. And some store it is. The painting is not 100% accurate, as I've construed, to put in a scaled down model of **Flying Scotsman** in the foreground, atop one of the blue racks. Also, as a contrast, I've put a model of the Planet underneath. Also 'included' are some other engines of note, including, if you can find them, four A4s. Platform 9¾ is a reminder of the close association beween railways and the cinema.

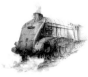

The drawing below is the **Flying Scotsman** as seen on its first viewing at the museum of the restored engine and on the right is a section of the big watercolour shown on the previous page. It is a made up 'section' of the drawing that I included as all the information and models of this engine are right at the back of the room.

'FLYING SCOTSMAN'
NRM YORK · 2016

LONDON & NORTH E
Nº 1564
DONCASTER
1923
RAILWAY CO

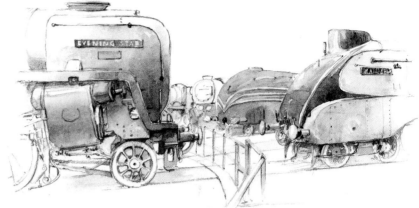

Though not in the NRM collection, the **Duke of Gloucester** 71000 was on an unscheduled stop at the museum sidings and with a chance visit that day I saw this engine, **Tornado** and **Evening Star** together — all in different shades of green.

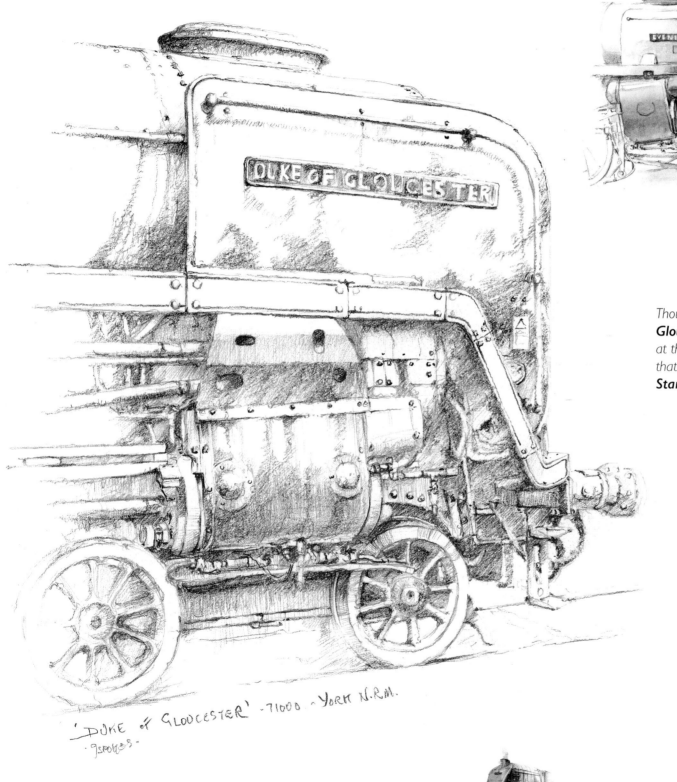

'DUKE of GLOUCESTER' -71000 - YORK N.R.M.
·9 spokes·

The 'Dwight D. Eisenhower'

The museum's list of steam engines is formidable. A big surplus has resulted in the creation of an equally impressive museum in 'Locomotion' — a sister museum based at Shildon near Darlington. The watercolour 'Blue Icons' was painted there.

The *Flying Scotsman* is now the York museum's number one showpiece and star attraction, surpassing even *Mallard,* although its running itinerary will leave it little time to be on static show to the public.

The NRM is a constantly evolving place that is never dull or dusty. Just as accessible as The Works is the new facility brought by the Search Engine, which is a must for accurate research.

Some years ago I started with a simple pencil sketch of *Mallard* and now from the footbridge of The Works gantry I am still sketching in this museum today and hopefully will continue for many years to come.

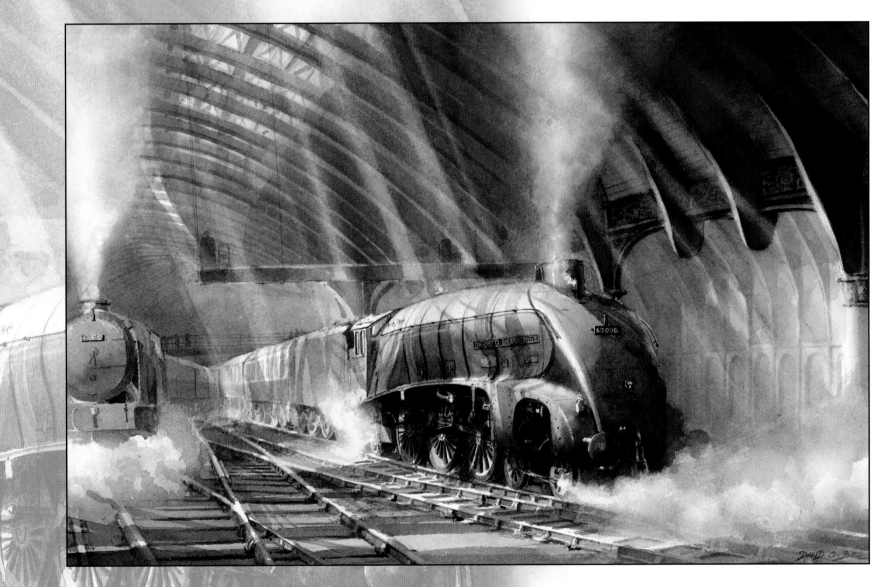

'Dwight D. Eisenhower'

A4 60008 York Station, north-bound

Another made up pencil drawing, and as with the drawing on page 72, with all the tones and composition worked out, and with the emphasis on sunlight and steam.

It's based on Newcastle station in the Fifties with **Mallard** centre and the A2 60512 **Steady Aim** on the right.

The 'Flying Scotsman'
A1 4472 & A3 60103

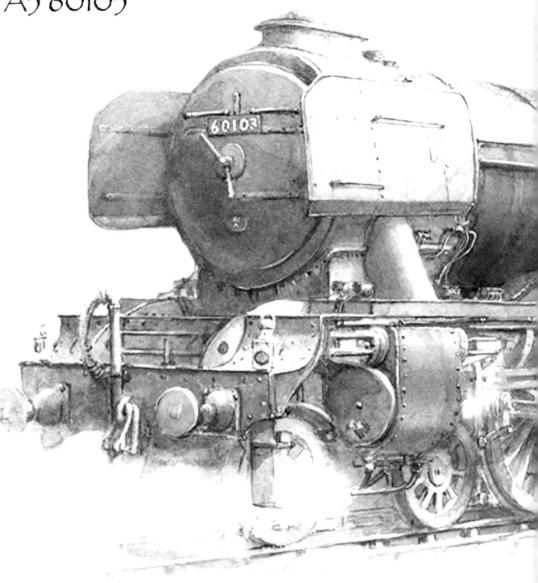

The 'Special One'

Following immediately on from the York miscellany but connected by its association and now ownership, I move on to one of the greatest steam engines in preservation — the *Flying Scotsman*.

It's not, of course, officially the greatest but I cannot deny that the *Flying Scotsman* is a very special engine. It is the only one of its kind to survive. The third built after the prototype Great Northern 'Pacific' engine — and the first to be greatly admired by the British public. It was named, confusingly, in 1924, after the daily London to Edinburgh 10am train service — the '*Flying Scotsman*'.

Not least of all it was the most aesthetic steam engine, in its final guise, ever built for the railways and, of course, the first engine to reach 100mph, officially.

Flying Scotsman was the creation and first masterpiece of Sir Herbert Nigel Gresley and his fellow draughtsmen at Doncaster for the then Great Northern Railway, in 1923. Built at Doncaster in 1923 as the A1 Class, and entering service on the newly formed LNER, it was to become the classic 4-6-2 Pacific.

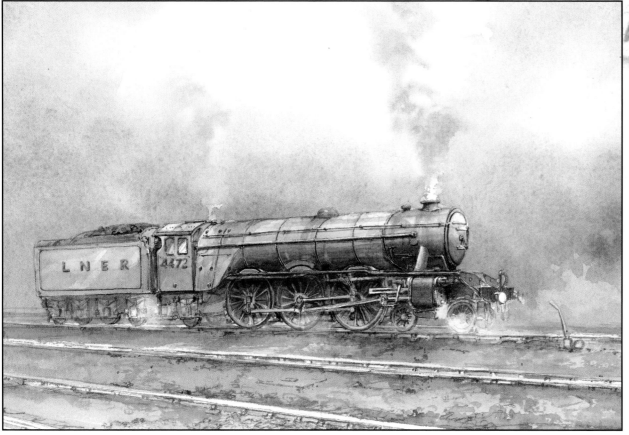

Flying Scotsman

This sketch is how **Flying Scotsman** *would have looked at the British Empire Exhibition at Wembley 1924–25 except the crest on the cab side has been replaced by its number, and LNER replaces the number on the tender.*

The first non-stop run was on 1st May 1928.

The non-stop service London to Edinburgh, starting in May 1928, saw the introduction of the 'corridor tender'. This was to allow a change of crew while still under full steam.

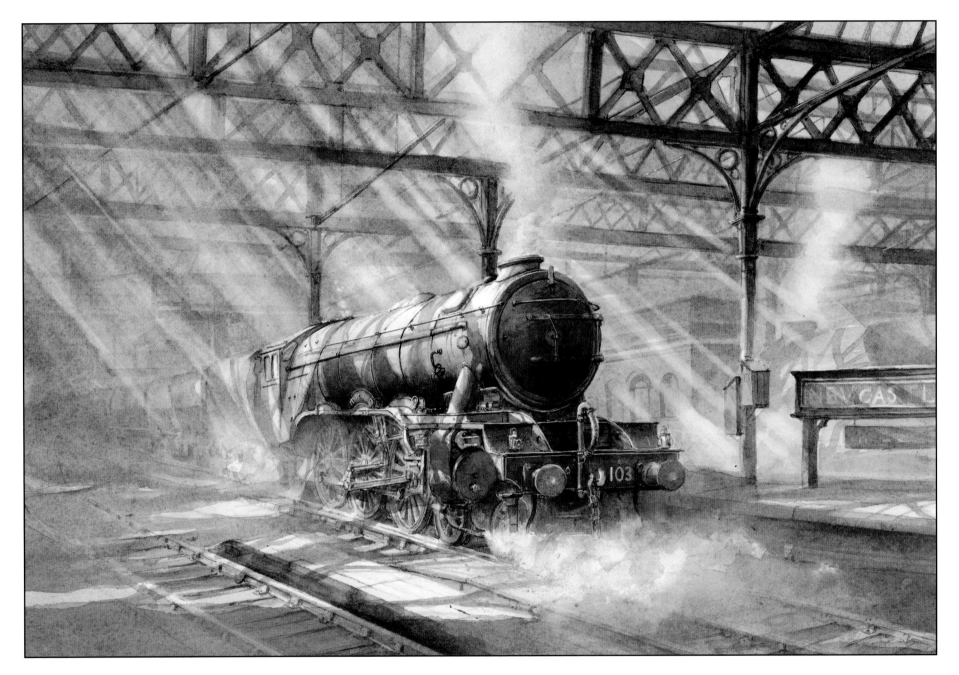

'Flying Scotsman'

Newcastle Station south-bound c1948

The UK railways had the standard 4-6-0 but it was only Gresley who, a travelled and forward-thinking man, had an interest in the 'Pacific', a term for the wheel arrangement 4-6-2. This locomotive was the development of adding two extra small wheels under the firebox, known as the 'pony truck', to take the weight of the ever growing fireboxes.

Gresley's first A1 was the *Great Northern*, 1470, named after the GNR and built at Doncaster in April 1922. It was then followed by 1471 *Sir Frederick Banbury* and 1472 the *Flying Scotsman*, which was about to make its first impression.

By chance it was available and selected to appear as a prestigious exhibit at the British Empire Exhibition, at Wembley, in February 1924, and the engine was renumbered 4472 with the name *Flying Scotsman*.

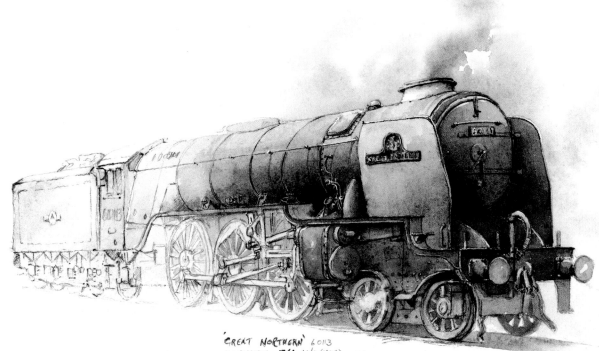

'GREAT NORTHERN' 60113
DONCASTER 1961 A1/1 (1945)

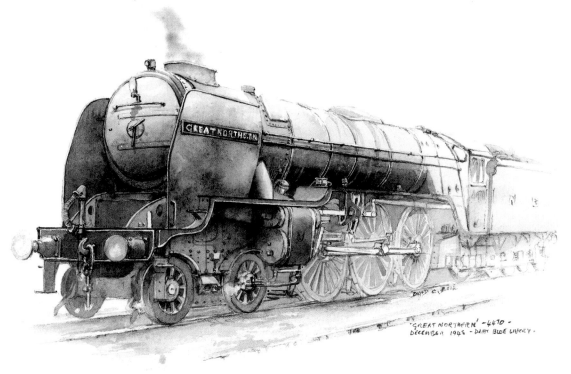

'GREAT NORTHERN' -4470-
DECEMBER 1945 - DARK BLUE LIVERY.

*Though the only part that remains is the nameplate, the **Great Northern** engine and what it initiated was an important time in Doncaster's railway history. The 'plant and shed' was, in my day, what Doncaster was all about and features at length in the local museum.*

The nameplate of this famous engine is on show at the museum and it is a great shame that the original engine was not preserved. It is really as important as the A3 we see today. The top sketch, as I saw it, shows the rebuilt engine at Doncaster, 1961, in its final days. The left-hand sketch shows an earlier variation of its nameplate and colour in 1952.

LONDON & NORTH EASTERN
No 1564
DONCASTER
1923
RAILWAY Cº

The resolute Gresley made improvements to the boiler and valve gear, and most significantly increased the boiler pressure from 180 lbs to 220 lbs. Gresley had wisely chosen the Walschaerts valve gear for each of the three cylinders and further improvement of the valve-gear by Gresley was introduced to all A1s and future A3s in 1927 to change to 'long travel valves' and the much more efficient, or shorter 'cut off' restriction of steam entering the piston.

These changes were made over the next four years until 1928, when number 2743 *Felstead*, (later 60089) was the first of a new batch, built at Doncaster, as the improved A3 Class. All previous A1s were subsequently rebuilt as A3s from 1942 to 1948.

Windsor Lad (60035) was the first built with a 'banjo' dome and this was the unmistakable symbol of all LNER Pacifics.

*This is the first sketch of **Flying Scotsman** to start the proposed 'Gresley Gathering' (see page 41). The other engines were just 'worked' into the same perspective, which turned out to be a difficult picture to contrive from a much higher eye-level than normal.*

35

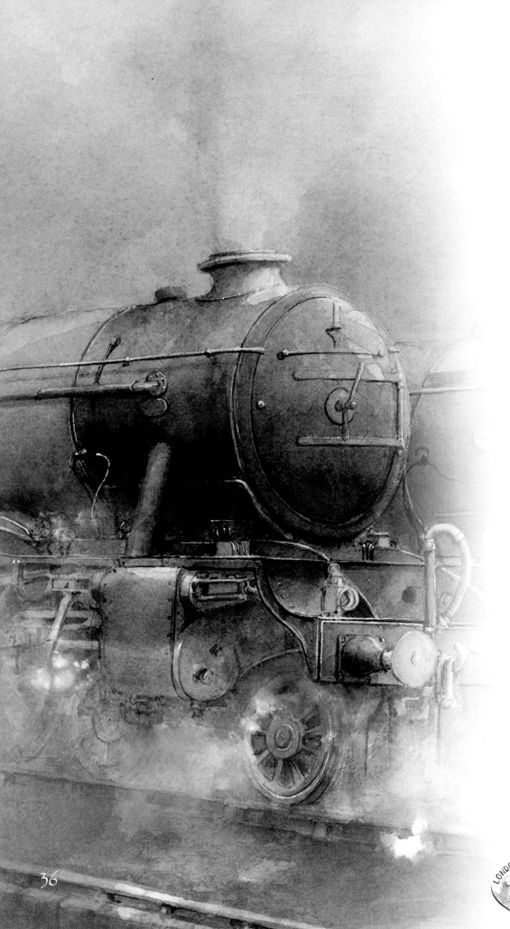

The difference between the later A4s, A1s and A2s was the A3(1)s' problems with smoke clearance.

The outcome, and, what was to become another characteristic of the A3, was the fitting of the 'Kylchap' double blastpipe and the extended chimney. The experiments include the full-size deflector that was to become the norm with the later Thompson- and Peppercorn-designed Pacifics, was not one of the modifications taken up for smoke clearance.

As they went through the works for conversion to the Kylchap double chimney, the resulting softer exhaust resulted in smoke clearance becoming a big issue again.

The solution was the innovative, and, unique to the A3s, fitting of the German/Austrian style smoke or 'trough' deflector, which the *Flying Scotsman*, recently released, is now fitted with. These deflectors remedied the smoke problem and gave quite a new look to the A3.

What the A3 had was a classic look, an almost perfect locomotive, but the classic A1/3 profile was not lost after this modification.

A1 ~ GREAT NORTHERN ~ APRIL 1922 · GNR ·
GNR APPLE GREEN GNR INDANITE BLACK WHITE LINING

LONDON & NORTH EASTERN
Nº 1564
DONCASTER
1923
RAILWAY Cº

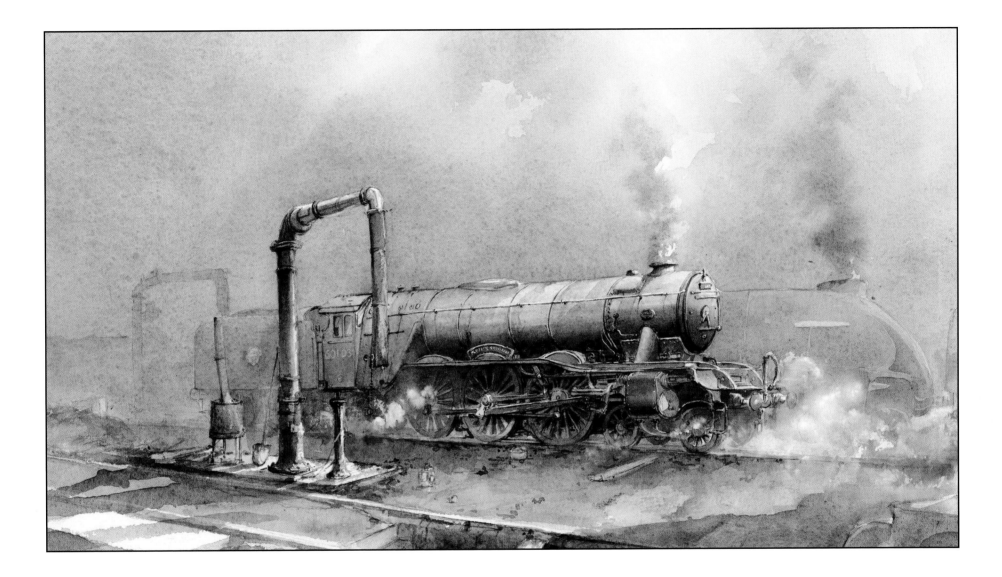

The Flying Scotsman

*This painting of **Flying Scotsman** is one of the few that I have done in the engine's short-lived blue livery. It would obviously put the date between 1949 to 1952. As engines entered the works they were out-shopped in the new Brunswick green livery over quite a period of time.*

... the 'Flying Scotsman'

It is very much a 'love or hate' change, but as time goes on we will see the the *Flying Scotsman* in all its variations.

The engine has superbly elegant lines, perfectly proportioned and has never been, as an unstreamlined engine, improved upon.

On an aesthetic note, and as an artist, the double chimney is almost flush with the smokebox door and looks very awkward. It would be better situated at least three inches back, or three inches smaller, or both.

By 1930 the *Flying Scotsman* had received quite a few modifications, including a new number on the cab sides, a curved tender, lower cab and chimney (due to loading gauge requirements), 'notched' buffer beam, and the removal of the buffer beam foot steps. Most engines were named after winners of horse races, hence there were some odd names.

LONDON & NORTH EASTERN
Nº 1564
DONCASTER
1923
RAILWAY Cº

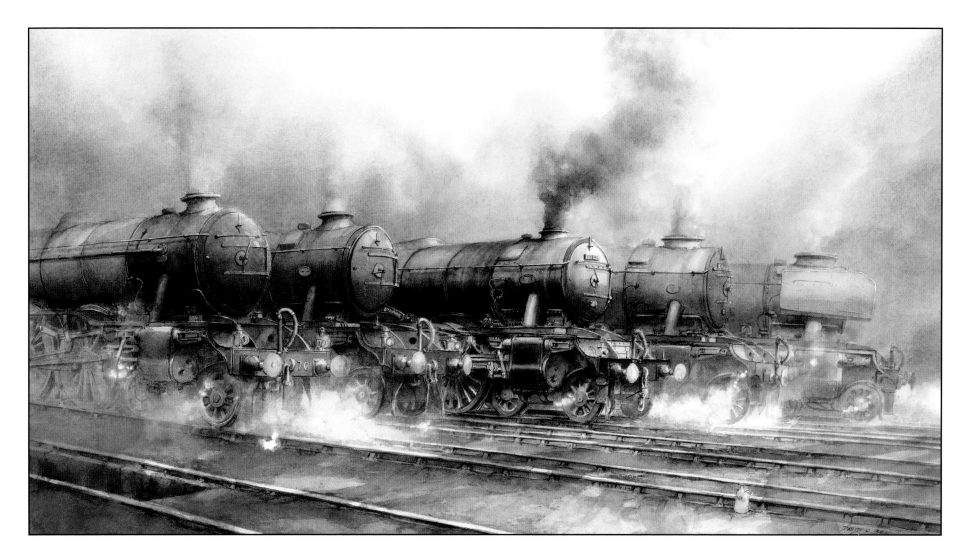

'On Track for Ninety Years'

Great Northern 1922, Papyrus 1935, Flying Scotsman 1952, Diamond Jubilee 1958, Galtee More 1961

This imaginary painting is symbolic of the A3 period and shows, from left to right, five engines starting with the original A1,1470, **Great Northern**, *next built as A3, 2750,* **Papyrus***, later as 60096. In the centre, the third and most famous of them all is A3* **Flying Scotsman***, originally No 1472, rebuilt in 1947 and now No 60103. The fourth is* **Diamond Jubilee***, built in 1924 as an A1 and rebuilt in 1941 as an A3, shown here with a double-chimney. The fifth is the A1 built in 1924 as* **Galtee More***, rebuilt in 1945 as an A3. This engine was the first to receive the German-style smoke-deflectors in late 1960. The painting is technically correct for all the engines at the dates stated.*

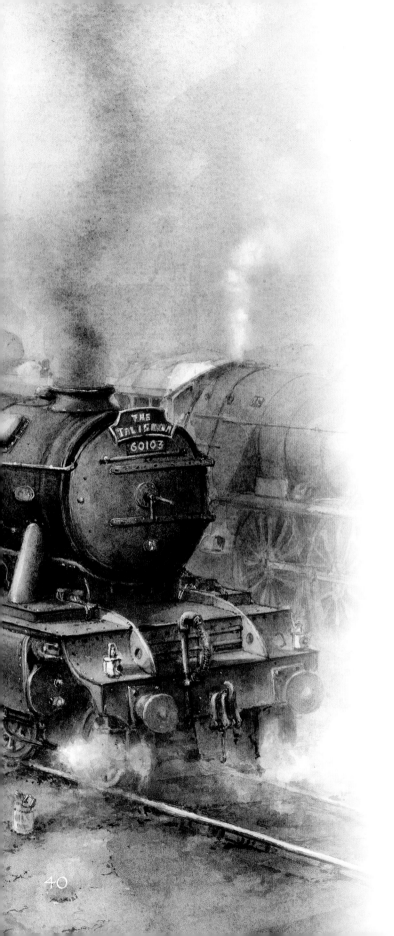

The Gresley Gathering
King's Cross Shed 1959

The engines from left to right are:

A3 60062 *Minoru*
A4 60022 *Mallard*
A3 60066 *Merry Hampton*
A3 60103 *Flying Scotsman*

All Top Shed engines.

The two visiting engines are

A1 60136 *Alcazar*
and A1 60156 *Great Central*

Both Doncaster engines.

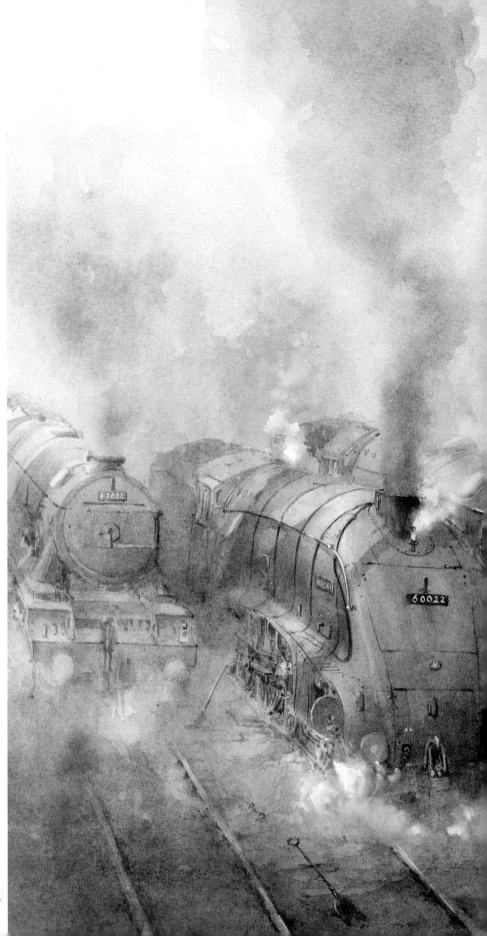

LONDON & NORTH EASTERN
Nº 1564
DONCASTER
1923
RAILWAY Cº

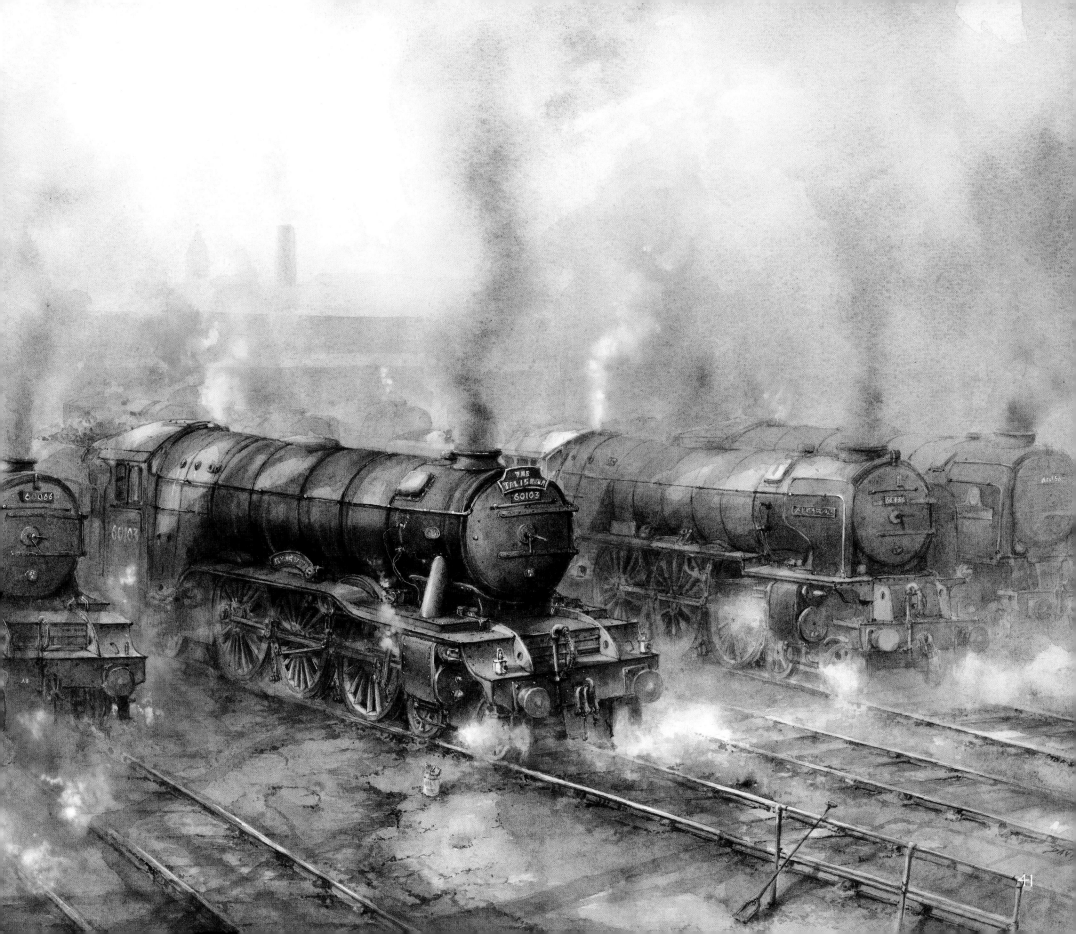

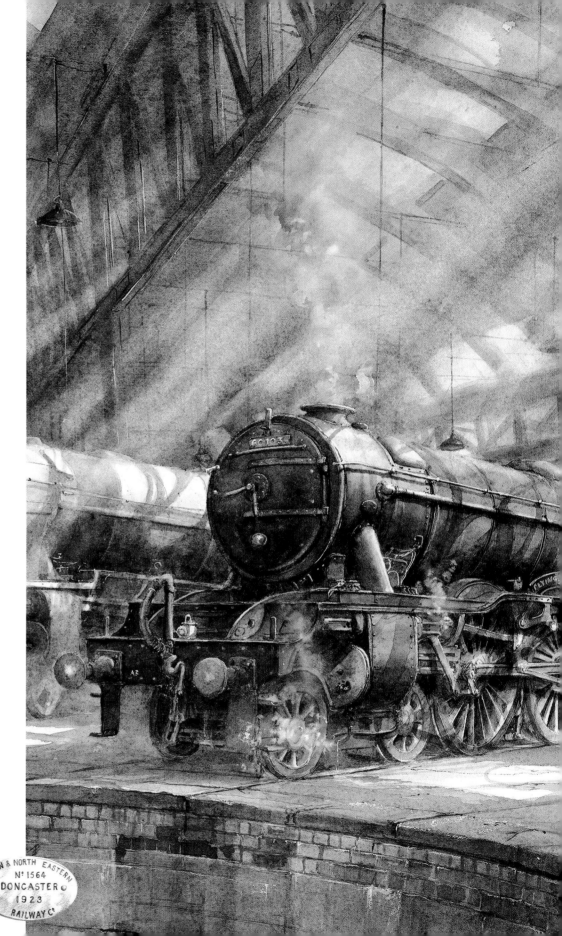

They didn't change to left-hand drive until the new batch of engines, twenty-seven of the, were built at Doncaster as the improved A3 Class. The 'conversion' from A1 to A3 started in 1941 and for obvious reasons was not completed until 1947.

Renumbering seemed to be an ongoing event from the first build, but it was a great help in keeping up with the many conversions. For instance, the *Flying Scotsman* started as 1471 (GNR), in 1924 it became 4472 (LNER), then 502 (1946), then the same year a quick change to 103, then E103. (The A3s were numbered 35 to 112, though the GN engine *Great Northern* became 113, later as 60113.) Finally, in December 1948, with British Railways, it became number 60103, which is what most of us can recall.

The colour scheme for non-streamlined engines was always Apple green for GN and LNER express engines until the war, when nearly all engines were then painted black, returning to Apple green from 1945 to nationalisation in 1948. Then the experimental BR blue livery for the short time up to 1952. Around that time you would see 'coats of many colours', and possibly all at the same time, as in the case of the LNER — their colours were Black, Apple green, the new Brunswick green and, the short-lived BR blue livery (with variations).

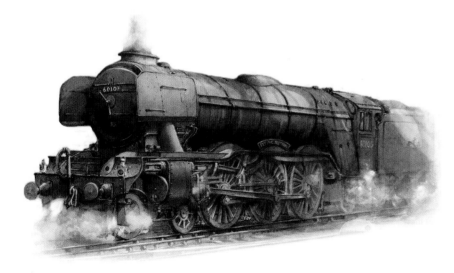

The A4 in the unique Garter blue also added colour to the scene. Finally the GWR colour of Brunswick green was selected for all express engines.

The A1 class were built from April 1922, the first being *Great Northern*, to the last one built as an A3, LNER number 2508 (60043) *Brown Jack*, at Doncaster in July 1934.

My descriptions in this book do not cover the vast amount of detail associated with the life and times of the A1/3 Class, far from it. I would need several volumes and a great deal of endeavour to do it. In any case, it's already been done by many renowned writers. The paintings and drawings retrieved from far and wide are the main feature of this book.

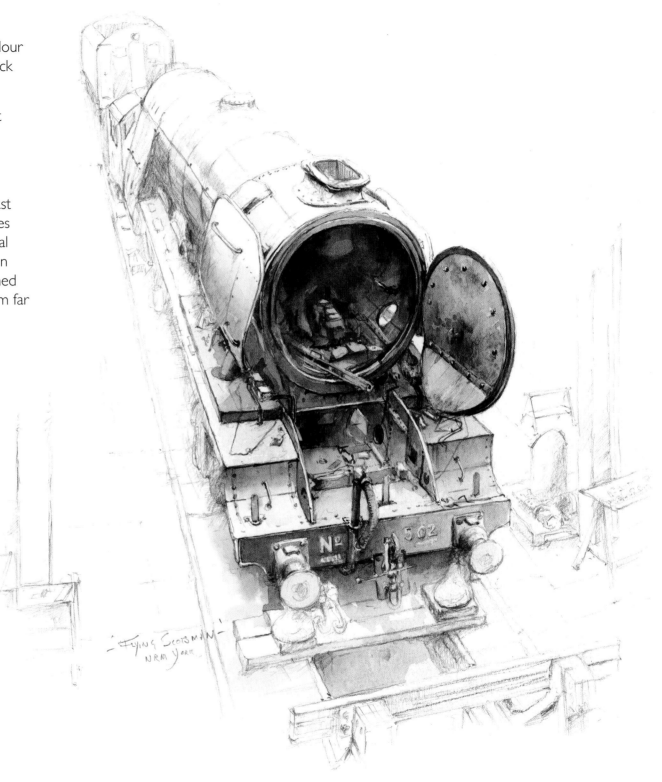

This sketch is a rare one. Painstakingly done in the 'Works' at the NRM, it was when the **Flying Scotsman** *was undergoing restoration in the museum's own workshop. I had intended to do a series of drawings from this spot showing its progress over the years, but it was not to be. Did anyone know then what was realistically planned and intended, and that the work would eventually be completed at Riley's in Bury?*

43

A very recent drawing, this time at the NRM, when at last the **Flying Scotsman** was put on show for all to see. Though it is accurate it did have a few pieces missing at the time as the engine is regularly maintained in a special display and service area at its York base.

It was originally bought for £3,000 in 1962 by Alan Pegler from British Rail and went through considerable financial difficulties. In 2004 the engine was purchased by the NRM and saved for the nation, quite rightly being called 'The People's Engine'. I apologise for not mentioning all those concerned in its survival, there are many, but the restoration and sight of this impressive feat of British engineering surpasses all. It's fortunate for me that the engine is now on the rails in time to be included and recorded for this book. I've had the chance to examine the engine in great detail and to sit in the driver's seat while the engine was still 'warm'. For this and access to many engines so that I have been able to create the paintings for this book I must thank the amicable and informative Clive Goult, ex-shedmaster at the NYMR and now 'caretaker' of the **Flying Scotsman**.

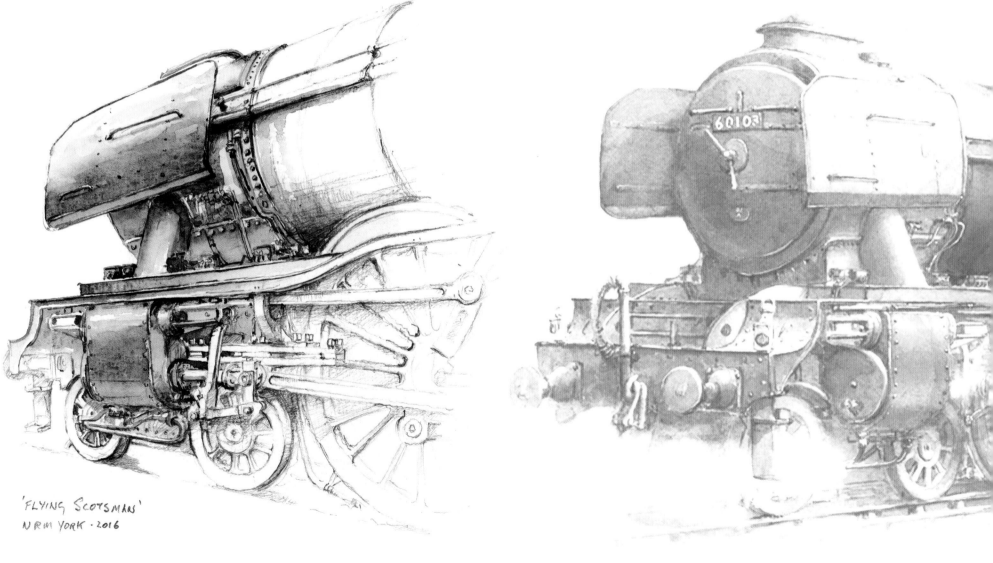

'FLYING SCOTSMAN'
NRM YORK · 2016

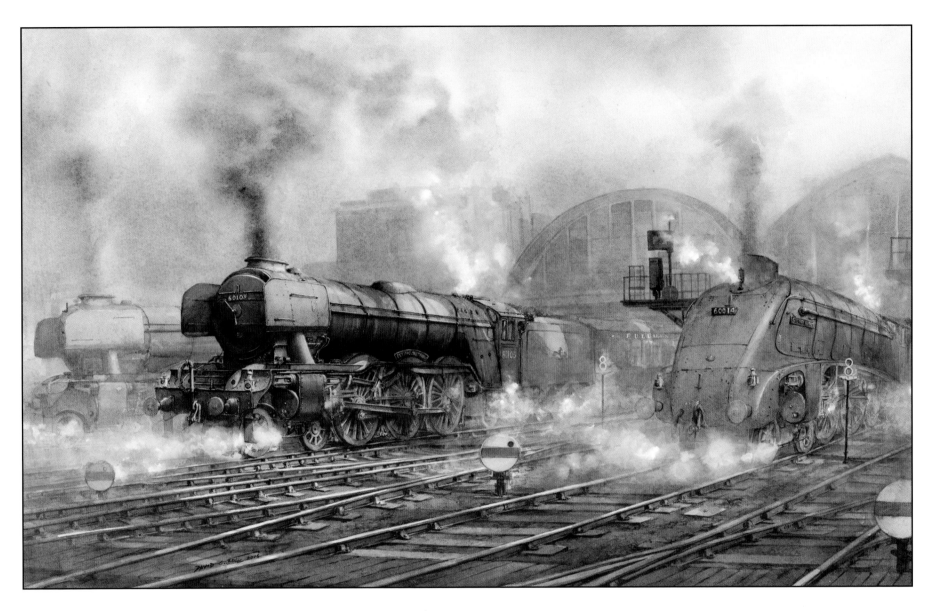

'Flying Scotsman'

Leaving King's Cross c1962

The final run was on 14th January 1963 from King's Cross with its new owner, Alan Pegler, on the footplate.

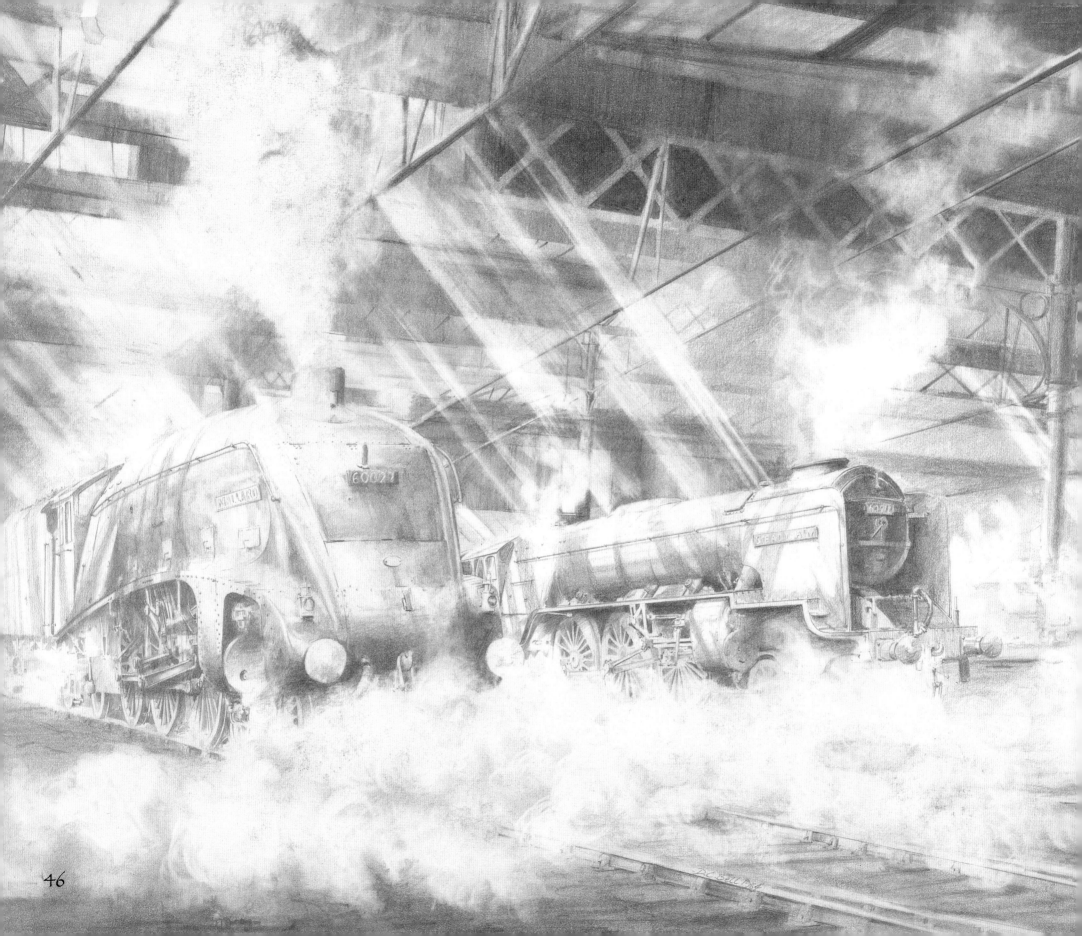

The 'North Yorkshire Moors Railway'

and its locomotives

BR Standard 4MT 4-6-0 75029 passing Grosmont Locomotive Depot, south-bound. Now named **The Green Knight**.

When you walk down the path from Grosmont station to the engine shed you enter a long dark and damp tunnel for 100 metres and emerge at the front doors of the shed itself. The tunnel was a minor masterpiece of George Stephenson and constructed when he proposed and built a 'track' suitable for horse-drawn carts from the port of Whitby to Pickering on the edge of the Yorkshire moors. So in 1835 the 'railway', powered by horses, was created, running from Whitby to Pickering, through the Grosmont tunnel itself —and was known as the 'Whitby and Pickering Railway'.

Another sketch at the coaling tower, it's the Thompson B1, 61002 **Impala.**

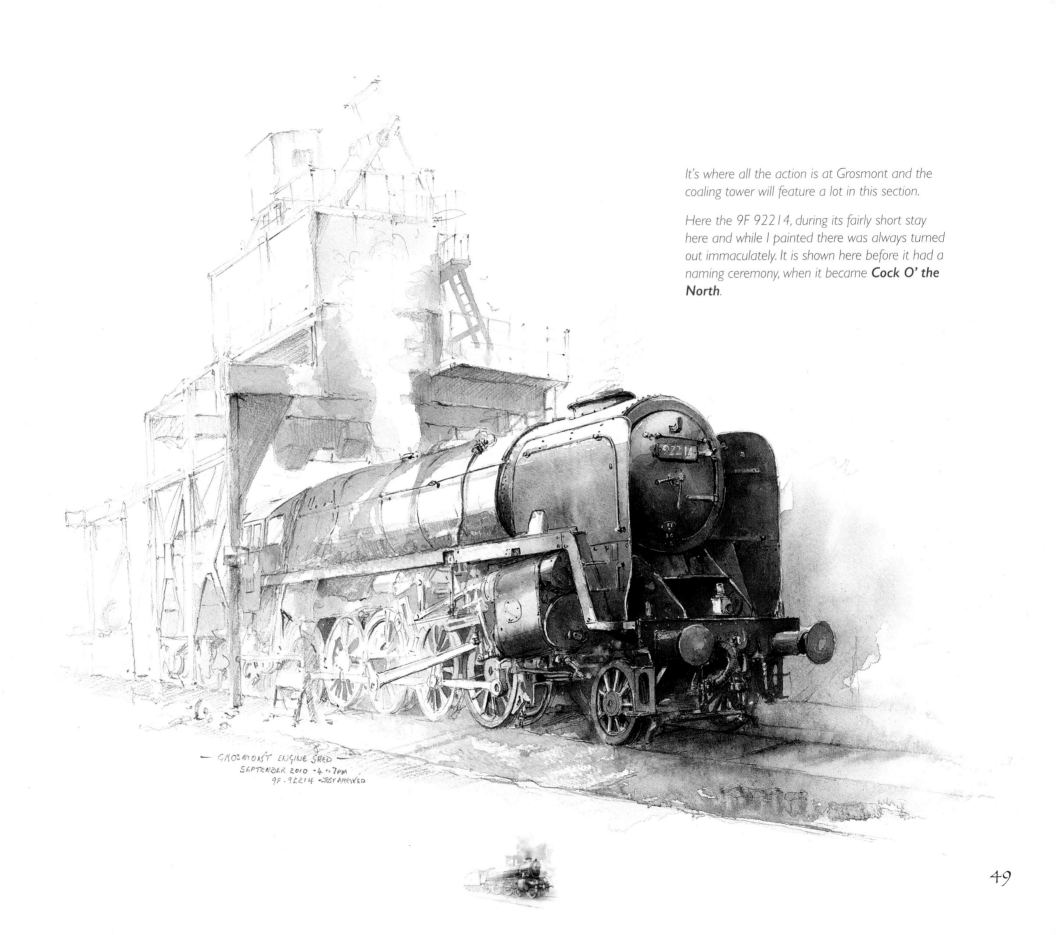

It's where all the action is at Grosmont and the coaling tower will feature a lot in this section.

Here the 9F 92214, during its fairly short stay here and while I painted there was always turned out immaculately. It is shown here before it had a naming ceremony, when it became **Cock O' the North**.

GROSMONT ENGINE SHED
SEPTEMBER 2010 - 4 - 7 PM
9F - 92214 - JUST ARRIVED

A great sight from Goathland station is watching and waiting for a steam arrival from Grosmont emerging from the severe gradient. Probably the most interesting part of the route is this considerable incline, at a maximum gradient of 1/11. In earlier times it was a considerable physical obstacle to overcome and still is. In the early days at Beck Hole, not forgetting it was still horse drawn and on an iron track, the gradient was overcome and ascended by the assistance of six-inch diameter rope and a pulley system, though later to be replaced by a static steam engine. It was nearer 1868, after a few line improvements, that included a big deviation on the Goathland incline, that 'steam' arrived in Whitby via the Goathland line.

A privileged sight at the shed was to see an engine like this storming out of the station tunnel to tackle the impending incline up to Goathland.

This time it's 9F 92214, then named **Cock O' the North**.

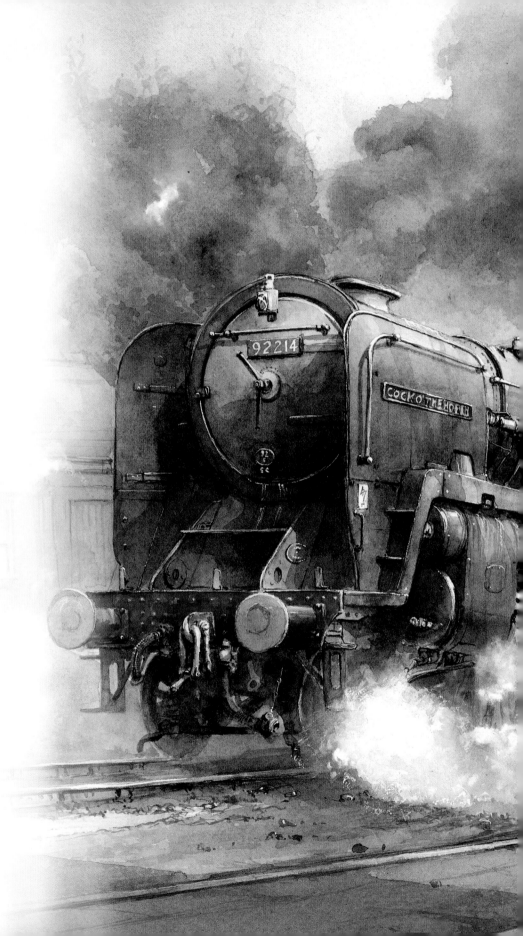

50

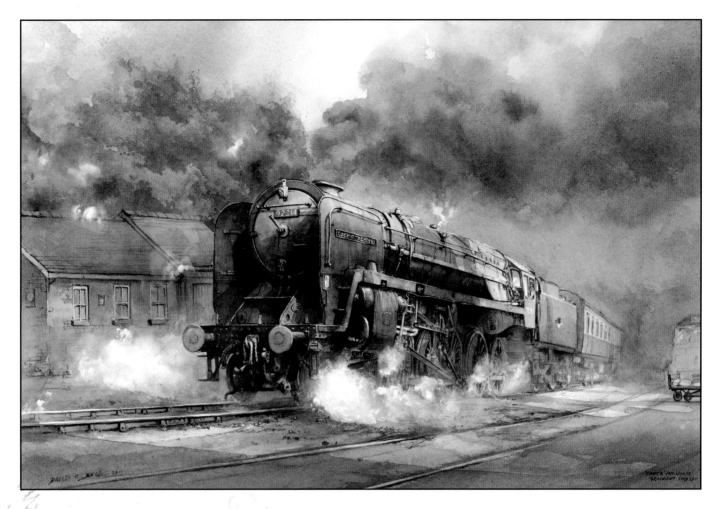

'Cock O' the North'

9F 92214 passing Grosmont Shed south-bound

From the original 1833 horse-drawn railway days, its development and expansion from Whitby to Pickering, and beyond, then a takeover by the York & North Midland Railway (Y & NM) in 1845, led to a prompt modernisation of the line, which in parts included a 'double track', and the widening of Grosmont tunnel in 1846.

The ups and downs of commercial railways and the impact of the Great War brought many changes to the railways.

The 1921 Railways Act created the four big railway companies and the lines around Whitby, Grosmont and Pickering became part of the London and North Eastern Railway.

The closures of many routes in 1965 saw the end of the W & P Line, although a BR line went from Whitby, to Northallerton via Grosmont and still does.

The NYMR society was formed in 1967 and after tremendous and dedicated work the line was opened for tourists and public alike in 1975. It is now one of the busiest and most established heritage railways in the U.K.

This is not quite what it seems as here I painted the **Sir Nigel Gresley** *and then I converted it to 60027* **Merlin** *some time ago for a possible new scene.*

The sketch on the right is a 'Black Five', No 45407. Seen most of the time at Grosmont, this is just one of the eighteen preserved engines of this class — from 842 of them built between 1934 and 1951. Owned by Ian Riley, and based at the East Lancashire Railway, it is named **The Lancashire Fusilier**.

45407
GROSMONT - FACING NORTH!

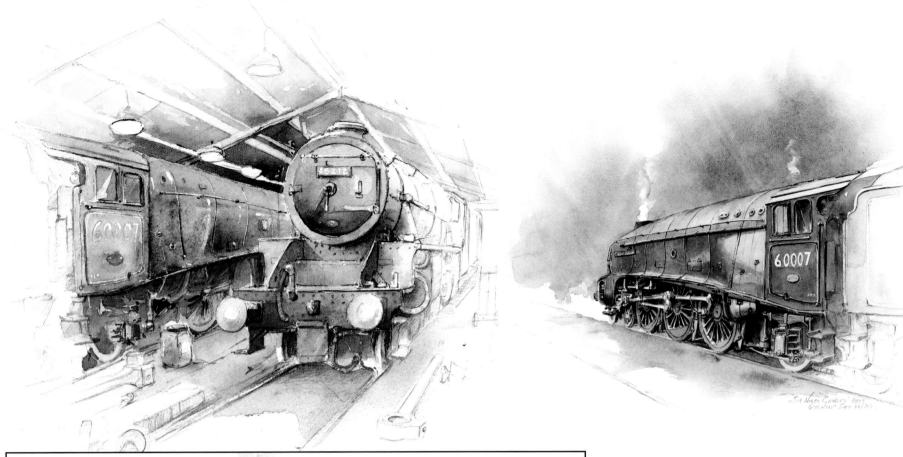

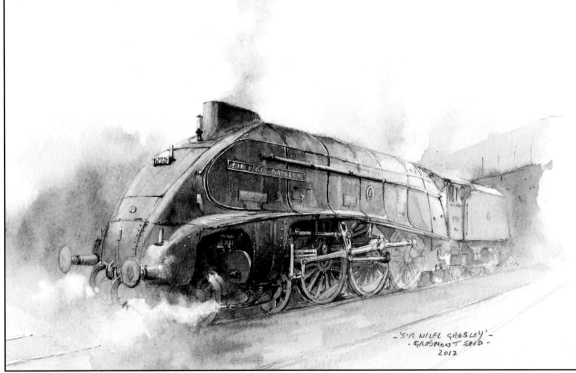

Small watercolour sketches done at the shed over the years. I usually now only paint outdoors in the summer unless a special visitor arrives in other seasons and makes for a worthwhile trip. All the engines face south as there are no turning facilities anywhere on the NYMR, as yet. The A4 engine **Sir Nigel Gresley**, 60007, is 'shedded' here, under the auspices of the Sir Nigel Gresley A4 Locomotive Trust. Not that I want to contradict myself but you may notice that the A4 60007 is unusually facing north, which I have to assume is for technical reasons.

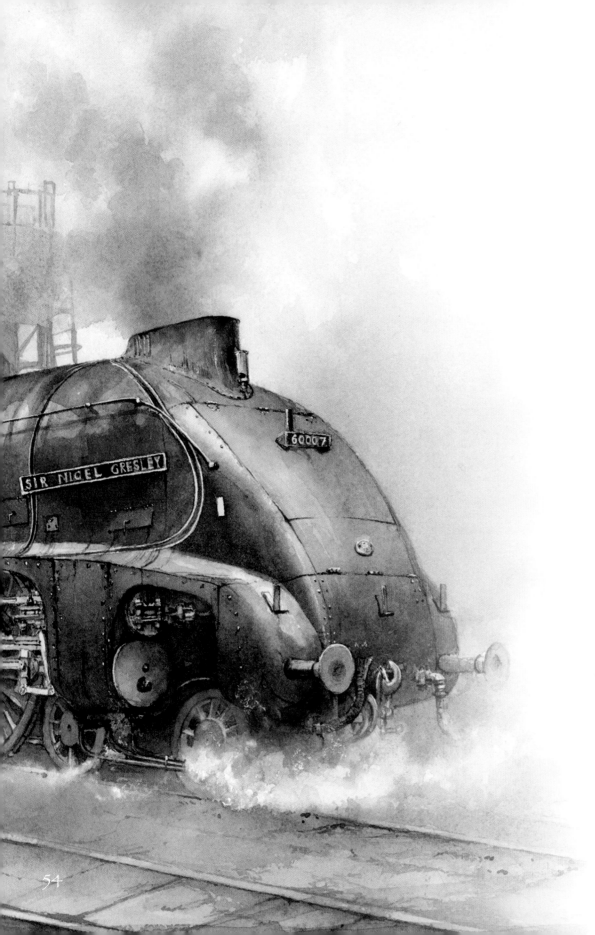

The *Sir Nigel Gresley* became my favourite engine of all time after a visit to Grosmont and the experience of a short ride on the footplate with the shed master, Clive Goult, and an introduction to its workings. This rekindled my passion for steam and I started a long, and productive, time in getting everything down on paper.

That's how I first got to know about the NYMR back in 2006 and subsequently got involved in drawing and painting at the shed with the great assistance of Clive, who literally gave me, free rein, within reason, to tackle these engines, big and small.

I've built up quite a collection over the years of this busy and well-established heritage centre, working in all seasons. A big thank you to Clive. Here are a few images resulting from many hours of very fruitful work.

This immaculately preserved engine is shedded here on a permanent basis with the NYMR. It has an above average pedigree in that it was the fastest post-war express passenger train at 112 mph, a record set on a scheduled run from Doncaster to London in May 1959. A plaque on the boiler casing sides remind us of this.

The engine was withdrawn in February 1966 and is now owned by the Sir Nigel Gresley Locomotive Preservation Trust Ltd. I have some great photographs of this engine at Doncaster shed in the early Sixties.

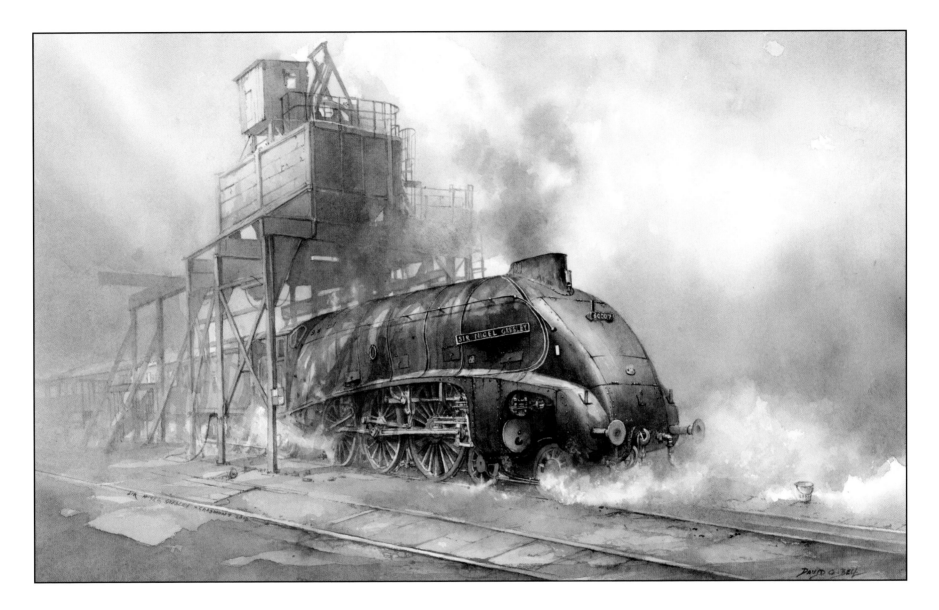

'Sir Nigel Gresley'

A4 60007 under the coaling tower at Grosmont 2014

This is the Southern Railway S15 Class No 825.

It was built at Eastleigh Works in 1927 and designed for heavy freight on the southern rails. This drawing was done a few years back, as the engine is now under heavy overhaul and should return to service in 2017. Two others of this class are stored at Grosmont and may also be restored at some stage. On a drawing note, as can be seen in this sketch I always draw verticals through the wheel centres — if you are 'out' on any measurement it will be in the correct shape of the wheels.

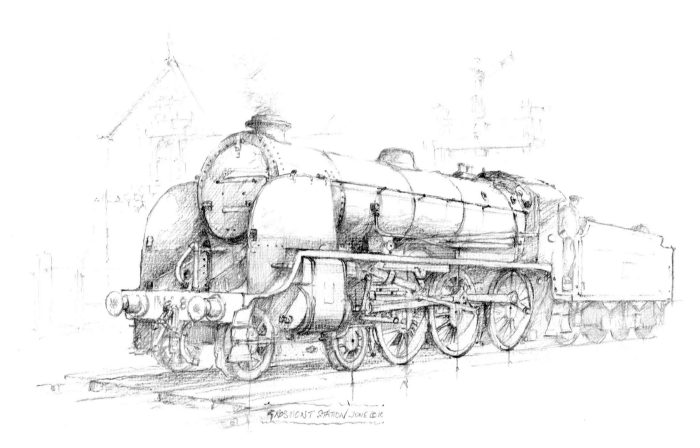

GROSMONT STATION JUNE '16

Built at Swindon in 1959, 9F 92214 worked on BR until withdrawn in 1965.

For a few years this immaculately maintained engine was a regular runner on the NYMR.

During that time it was strangely named **Cock O' the North** in 2011 by its owners, though now it is has a new keeper and resides on the Great Central Railway.

This is one of many pencil sketches at the Grosmont depot.

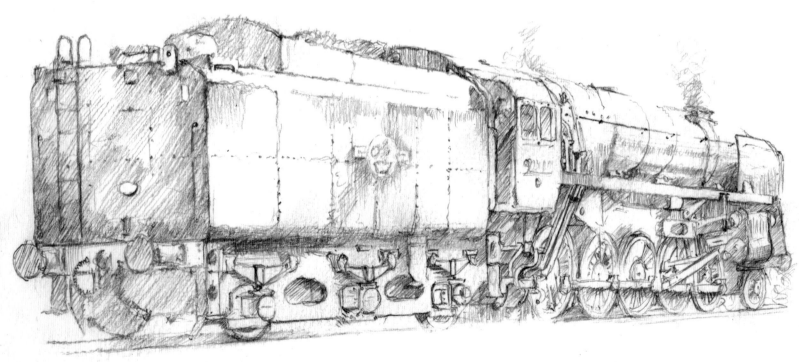

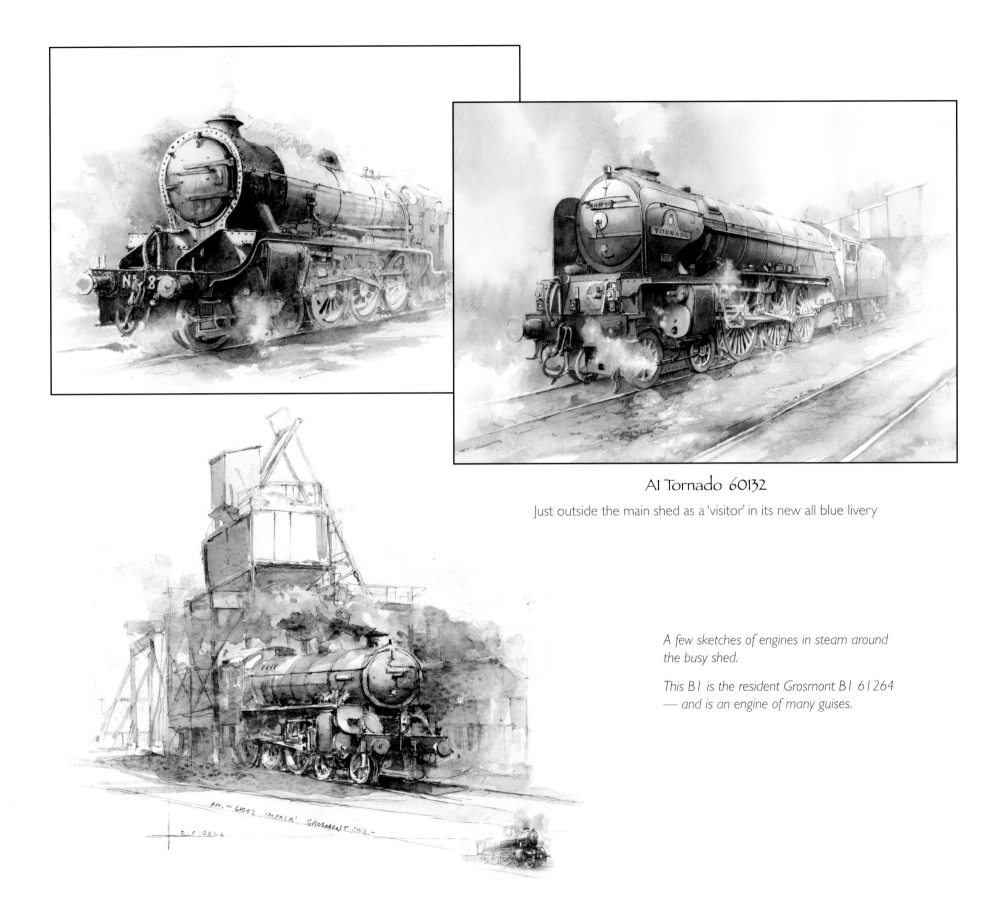

A1 Tornado 60132

Just outside the main shed as a 'visitor' in its new all blue livery

A few sketches of engines in steam around the busy shed.

This B1 is the resident Grosmont B1 61264 — and is an engine of many guises.

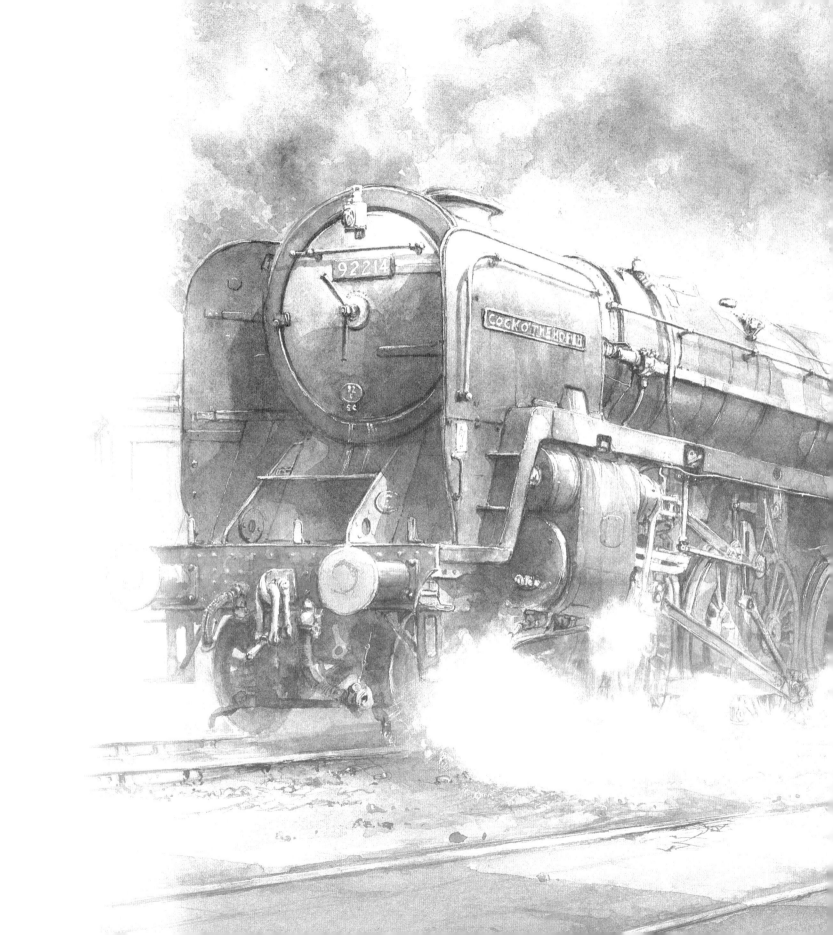

The 'Duchess of Sutherland'

and the Coronations

The huge change of grouping in 1923 saw the 'big four' being formed — one of which was the LMS (London, Midland and Scottish) railway. The 'neutrality' of the GWR engineer William Stanier saw him selected as the man to unite this group and he became the chief mechanical engineer of the LMS in 1932. Stanier had been the main assistant to Charles Collett, the GWR CME, and the opportunity of becoming CME of the LMS was taken without any hesitation.

Like Gresley and the LNER, Stanier was to personify the LMS.

During ten years at the GWR Stanier was influenced greatly by the design of the powerful King Class. The four cylinders, boiler pressure and even wheel size all figured in his LMS designs. The difference was the change to the Pacific wheel arrangement, 4-6-2, which would have to support the much bigger boiler and firebox.

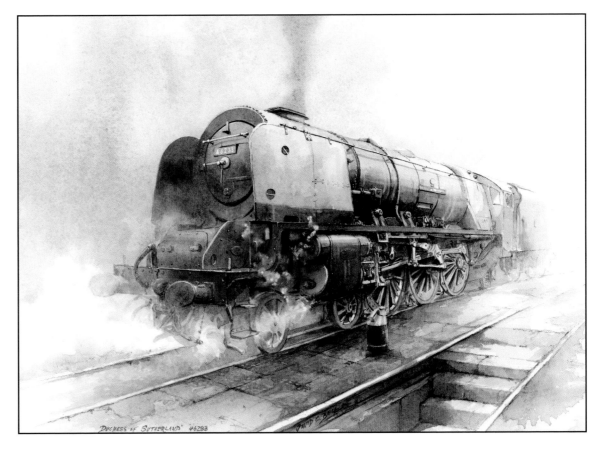

'The Duchess'

46233

As can be seen in the foreground, this painting was also known as 'The Green Can'.

This next selection of paintings features the Stanier Princess Coronation Class 4-6-2 express passenger engine and in particular 46233 *Duchess of Sutherland*.

The first prototype engines were the 6200 *Princess Royal* and 6201 *Princess Elizabeth* both built in 1933 at Crewe. Another eleven were built and entered into traffic between 1933 and 1935.

6233

7 P

As seen at West Shed, this painting shows the wheel arrangement of the Duchess.

DUCHESS OF SUTHERLAND
6233 - BLACK LIVERY
RLY - WEST SHED 2011

DAVID G. BELL

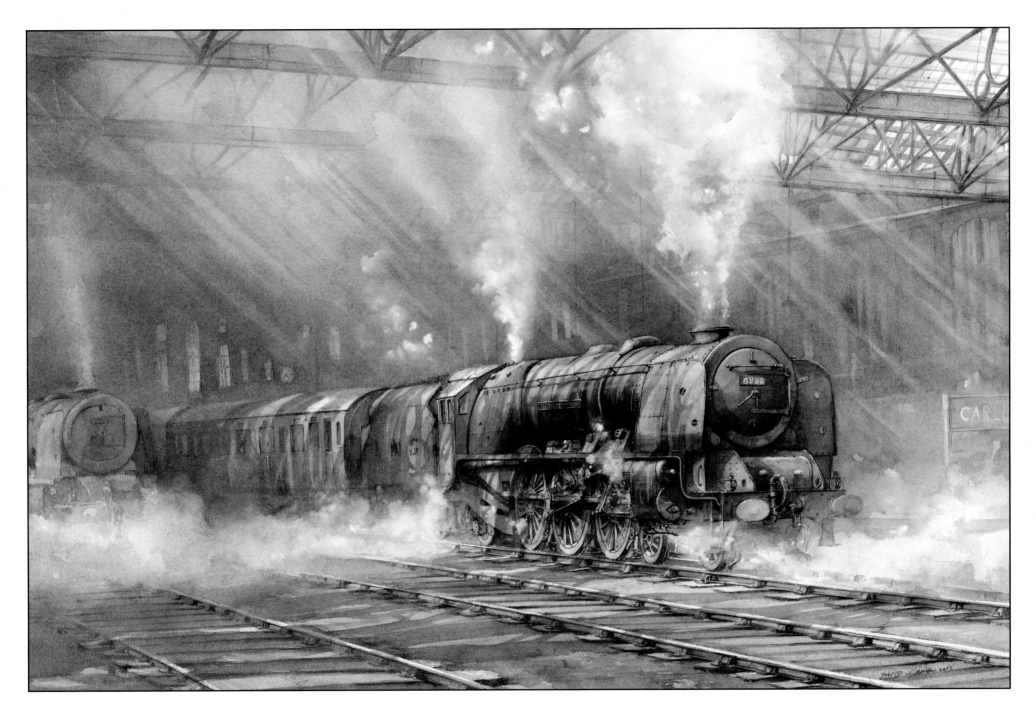

'Duchess of Sutherland'

Carlisle–Citadel south-bound

Stanier's priority had been the design of an engine for the demanding West Coast Route, Euston to Glasgow/Edinburgh, which the LMS operated.

The first of the new batch was 6203 *Princess Margaret Rose*, now also preserved at West Shed, Butterley, alongside the *Duchess of Sutherland* and both owned by The Princess Royal Class Locomotive Trust.

The process of change from the Princess Royal to the Princess Coronation Class was through the building of improved and better engines and so the new class of Princesses began in 1937. Stanier, with his assistant Robert Riddles and the chief draughtsman Thomas Coleman, all brilliant engineers, improved the Princess Royal class and this is how the new engines, now the Princess Coronation Class — or, as we know them, the 'Duchesses' — came about.

The 'Duchesses' also had the awesome task of hauling a heavy passenger stock for six and a half hours at a high and continuous speed on the London to Glasgow line. This train service on the West Route was known as the Coronation Scot, and was introduced and named after the coronaton of King George VI, commencing in July 1937.

'Sir William A. Stanier FRS'

46256 Euston 1959

Built as a non-streamlined Coronation Pacific and one of the last nine Coronations built at Crewe — all 'conventional' and with double-chimney and smoke-deflectors.

Neither a 'Duchess' or a 'City', this engine was uniquely named after its designer and sadly not preserved, being withdrawn and cut up in 1964. Originally painted black, then blue, green and finally, as seen here in the painting on the right, in the striking red of 1958.

Sir William *spent most of its time at Crewe and Camden sheds. It is shown here in this watercolour leaving Euston Station c1959.*

*Sketchy yes, but this is just a detail of the **Duchess of Hamilton** from the NRM panorama and to the right one of it's 'classy' lamps.*

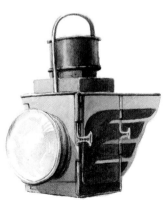

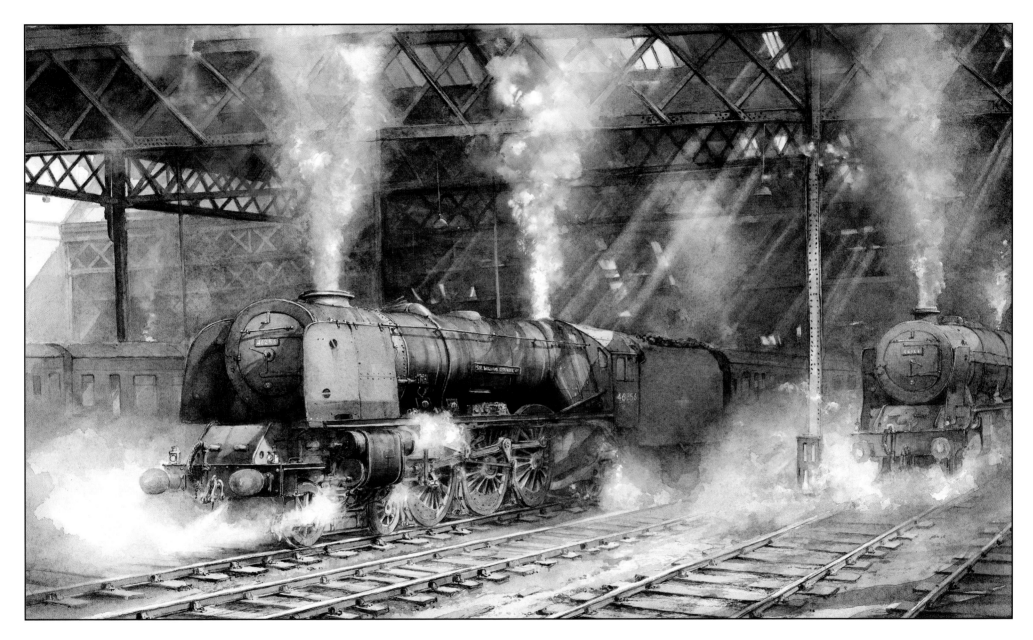

Sir William A. Stanier FRS

46256 Euston 1959

The LMS decided to introduce, as the opposition the LNER had done with the A4s, a streamlined version of the Princess Coronations for the prestigious West Coast route. The shape was decided after extensive tests in the wind tunnel at Derby. What is now seen on the *Duchess of Hamilton* at York is the final version, showing the shape of engine and tender and the striking livery.

The practicalities of streamlining was a big problem. The engines needed constant maintenance and the cost of time and in getting at parts enclosed by the streamlining was a big negative.

Eventually, after the war, all streamlining was permanently removed. I'm not an admirer of this style and neither was Stanier, and when the casing was removed in BR days it was a sight to behold. I make the comparison with the valances removed from the A4s, the engines looked the part with all the wheels and motion on show.

As with the A3s, the introduction of the deflector was very significant. The Duchesses had a huge deflector that greatly improved their looks. The *Duchess of Sutherland* was the first to have the modification of a double-blastpipe and chimney in 1941.

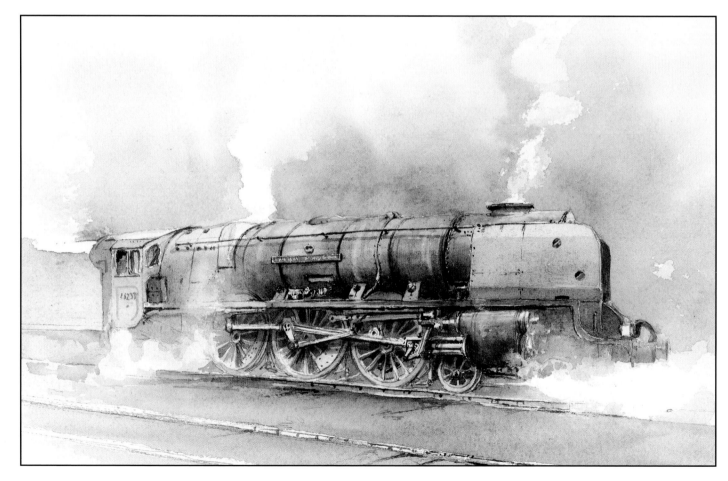

'The Duchess'

One of the sketches on site at West Shed in 2012 for the larger finished watercolour on the next page.

The modification of a double blastpipe chimney in 1941 and then the fitting of smoke deflectors in 1946 was a major change in the 'look' of the engine. Like the A3s but placed further back, it was a great improvement that immensely enhanced the image of the engine.

The 'Duchess of Sutherland'

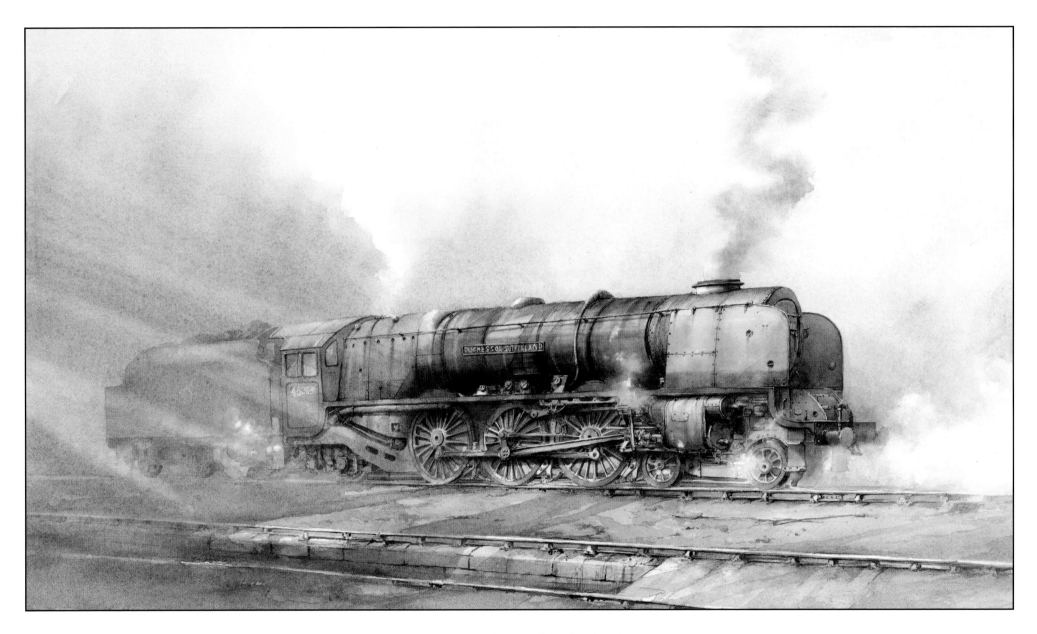

46233 'Duchess of Sutherland'

Class 8P 4-6-2

This is the watercolour I mentioned earlier of the striking profile of this Pacific. Painted 2012.

Due to the willing assistance of Les Truswell at the West shed, I have developed a great affection for this engine, having had footplate rides, admittedly at slow speeds, and trips throughout England over the past few years. A great engine to paint, the *Duchess of Sutherland* is now residing and maintained at West Shed, Butterley.

A change in livery is an important and very significant point in painting any engine, in an artistic way.

The *Duchess* was built in 1938 at Crewe Works and was one of the first five non-streamlined engines.

The *Duchess* 6233, emerged new, non-streamlined, and painted in lined out Midland red. Previous engines built with streamlining had a varied livery of blue with four white stripes from the front buffer to the rear of the tender and later red, i.e. 'Crimson Lake' (LMS), with gold stripes. Coaches to match.

The non-streamlined engines, including the *Duchess,* were painted in various liveries over the years. The first was Midland red livery with black and gold lining. Next, during the war 6233 was still red, but with no lining and then in 1947 it was painted gloss black with cream and maroon lining. The numerals were now the familiar plain Gill Sans typeface, unshaded. The third livery was after the Heavy General repair at Crewe in April 1950 and emerged in the interesting Caledonian blue livery. It was basically as the first 1938 red livery, except for the black–blue and white lining.

The *Duchess* has yet to be painted in a blue livery in its preserved state.

After a Heavy General in 1952 the *Duchess* once again emerged in a new livery. This was after nationalisation and it was painted in the standard BR green. All the lining including boiler banding was the superb black and orange lining, as applied to all Pacifics. Most of the sketches and paintings are in this colour.

Finally, another Heavy General repair at Crewe in September 1959 and the slight change to Brunswick

green as it became known. The tender now had the new BR crest. I first saw the *Duchess*, in steam, on shed at Butterley in black livery, which I greatly admired but I have never done any major paintings in that colour. It was quite outstanding to see its repaint to Brunswick green. This was much more appealing to me and I immediately painted the engine in profile, as seen here, along with many other works. I have also included several drawings and paintings of her in red and green liveries as I remembered them from spotting days. Hopefully in the next book we will see her in a blue livery.

The history of the *Duchess* from withdrawal in 1964 to today is one of fortune and fortitude. It was purchased by Butlin's and put on static show outside at the Ayr camp in Scotland. Much later, an approach from the Bressingham Steam Museum to acquire the engine was made and the outcome was fruitful. Butlin's had decided to replace and release these outdated tourist attractions and saw Bressingham as the next 'custodian' of the *Duchess*.

Eventually, after seven years on the beach, in March 1971 the engine was successfully transported 400 miles on a rail and road journey from Ayr to Bressingham, via Norwich and Thetford — a mighty task. Many thanks to Sir Billy Butlin.

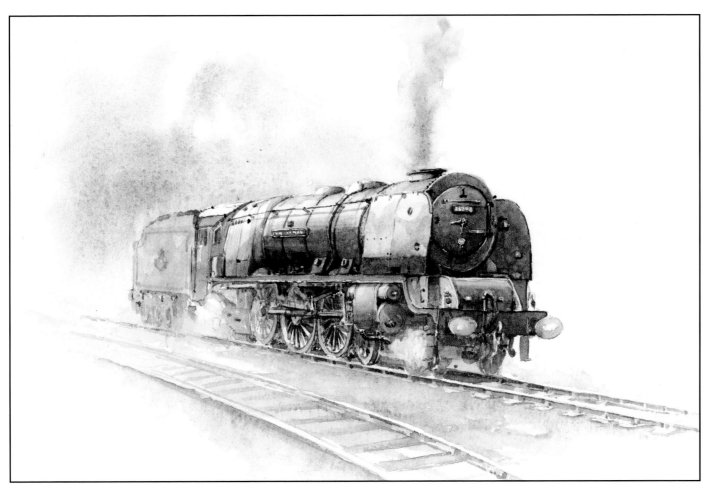

A watercolour sketch of the Duchess outside the shed at Ripley. The engine is now in BR green and is a superb spectacle of locomotive engineering.

Also, amazingly, the *Princess Margaret Rose* from the Minehead camp and the rebuilt *Royal Scot* from Skegness were saved. It was at Bressingham that I had my first sighting of these great LMS engines in preservation and an enjoyable steaming through the gardens with my family and with driver Bloom at the controls.

The *Duchess of Sutherland* was meticulously restored to full working order by October 1974. The engine, now owned by the Bressingham Steam Museum, was again to be moved to new grounds. In 1995 a major decision was made by the Bressingham trustees. They had agreed to sell 6233 to the Princess Royal Class Locomotive Trust (PRCLT), which had already acquired the *Princess Margaret Rose*.

All involved agreed the future of 6233 was at West Shed, Butterley, and, terms agreed, it arrived by low-loader and was transferred to the shed on 4th February 1996. In 1998 the task of a major overhaul commenced and it was that new institution, the National Lottery Heritage Fund, that gave a substantial grant towards its restoration and a two-year completion date.

After the rebuild the engine was fired up in January 2001 and at last moved under her own power again over 20 years since her days at Bressingham.

Tested successfully on the mainline on 4th July 2001, the *Duchess* made her first loaded and revenue earning run on 18th July from Derby.

The huge team involved in the restoration cannot be praised enough. I like creating lots of things but the scale and variety of tasks involved at the West Shed was colossal and would deter most.

First at Ayr then Bresssingham, and finally settled at Butterley, I can now present from my time at West Shed a few paintings and drawings of this magnificent engine.

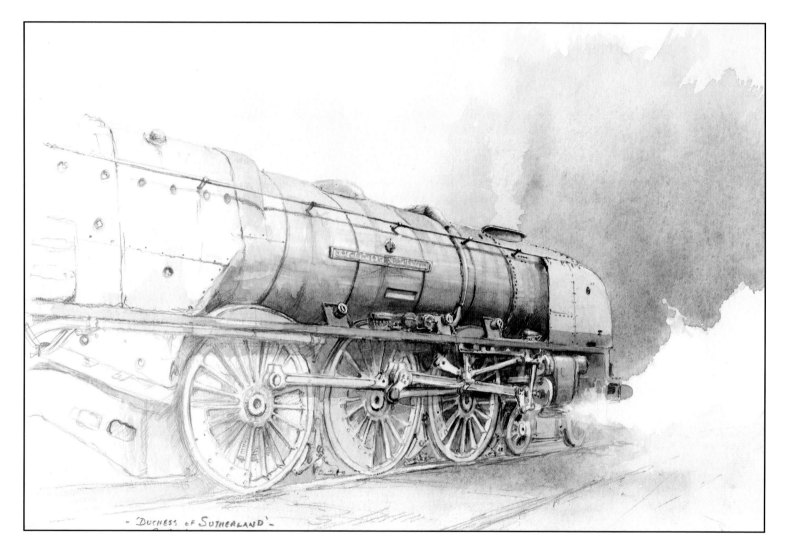

- DUCHESS OF SUTHERLAND -

Another one of those blue/grey paper sketches. The engine had a double blastpipe chimney fitted in 1941 and is still like this. Not until 1946 were smoke deflectors fitted.

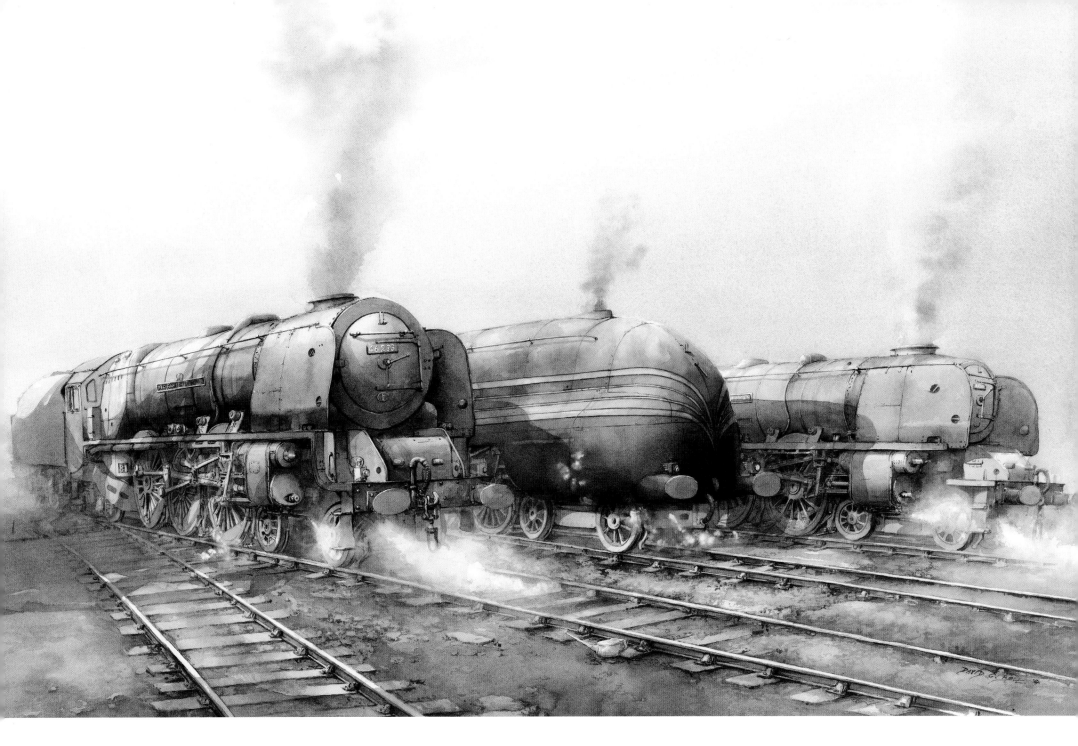

'Colours of Steam'

Of course, a contrived painting simply showing the three preserved Coronation Pacifics in three different liveries. In its fourth livery of Brunswick green is 46233 **Duchess of Sutherland***, in the middle in red and gold livery is* **Duchess of Hamilton***, 6229 and on the right is* **City of Birmingham** *46235 in the 1950–52 Caledonian blue livery.*

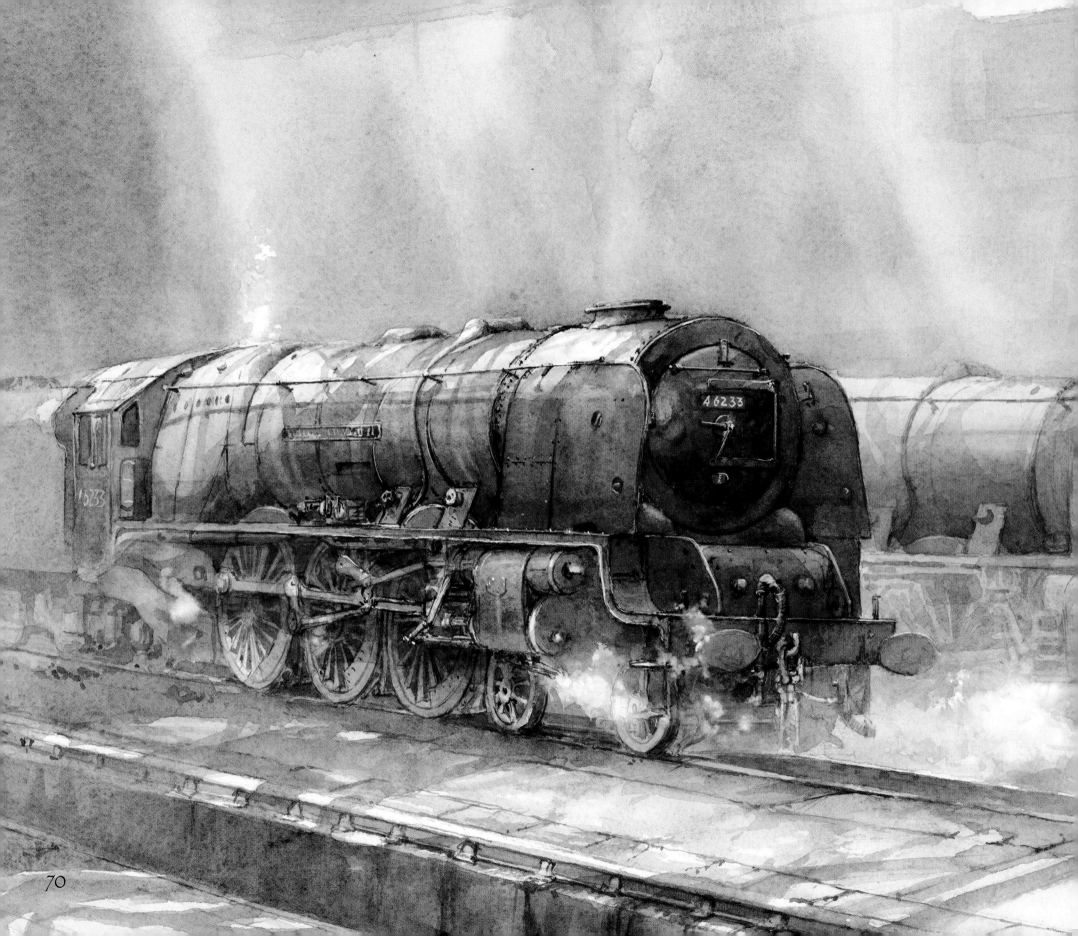

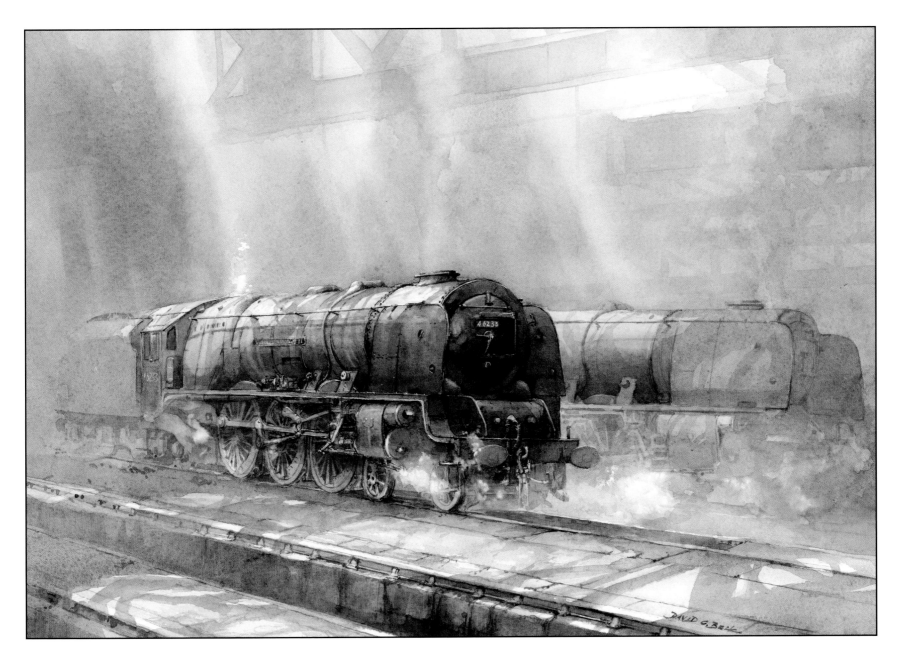

'Duchess of Sutherland'

Carlisle Kingmoor shed 1952

*This is another watercolour painting of **Duchess of Sutherland** seen at Carlisle Kingmoor Shed in 1952.
It was only blue between May 1950 to November 1952. This preserved engine makes mainline tours
throughout the year under its own trust of Princess Margaret Tours.*

This is a made up and final pencil drawing, with all the tones and composition fairly well established, of an interior shed scene with the emphasis on varying shades of light coming down. It's based on Camden shed in the mid-Fifties with a Coronation 46235 *City of Birmingham* centre and a 'Jubilee' class on the right. I usually prepare for most large watercolours like this, although I have been unable to track down the original watercolour, which would have been ideal to show the next stage.

The 'Doncaster Carr Loco'
and King's Cross Shed and some of its engines

From the introduction of the Standard classes by Riddles in the early Fifties to the last of the 9Fs in 1959, the 'Age of Steam' seemed to plummet to its end very quickly and by the mid-Sixties it was all but over. I never realised it would happen until I saw, in shock, an A4 slowly hauling a 'freight' train through Doncaster station. Even though at the same time I was, unashamedly, as excited when a Deltic flew through the station as I was seeing a Pacific-hauled express. I never really thought there would be a day without steam.

However a few years later in the mid-Sixties, I moved, schooling wise, to Trinity House Navigation School in Hull until I went to sea as a cadet in 1968. The emphasis shifted then very much to ships and the sea, but I never lost my interest in steam engines — far from it. The difference was that I lost contact with fellow steam enthusiasts and therefore what was really going on.

That is until I went fishing, as I often did with my school mates, down at the commercial docks on the banks of the Humber. One weekend, there, to my horror, at a great spot to cast your line, was the sight of several engines including A1s, A2s and A3s being cut up. Unknowingly I was at 'Draper's Yard' where anything metal was bought and cut up for scrap. I was unaware that not only were the great engines I had being pursuing for many years here but they were now almost razor blades! An engine void of 'boiler and tubes' was not a pretty sight. But it still never registered that the end of steam was nigh. In no time I was off to sea. It was these years at sea on the other side of the world that cushioned my acceptance, almost ignorance, of the mass removal of engines. I was saved from this fact for a while.

Strangely it happened nearly twenty years later when, after my time at sea and while at Art College in Hull, that I went down to Draper's Yard to draw and paint. This time it was all the 'local trawlers' that I had seen built around Hull and actually fitted out in Humber dock in front of my school ready for sea trials, a daily sight for three years. Now in the Eighties they too were meeting the cutter's torch. Strange world we live in.

But, as a boy, it was Doncaster Shed and the 'Plant' that was the Shangri-La of the world of steam. Strange that, although platform two at Doncaster station was a great place to be spotting trains, the shed and plant was where you had to go. It was my favourite place in all the world and I used to cycle 25 miles most Saturday mornings to get there.

Diamond Jubilee 60046

Built in Doncaster in 1924 as an A1 and rebuilt as an A3 in 1941. Shown here in blue livery at Doncaster shed. Though first allocated to King's Cross, the engine spent most of its life at Grantham and Doncaster Sheds. Withdrawn in 1964 and was one of the Pacifics I saw being scrapped at Draper's in Hull in 1965.

As it seemed a significant engine and a perfect subject, I painted this for the Queen's Diamond Jubilee commemorations in 2013.

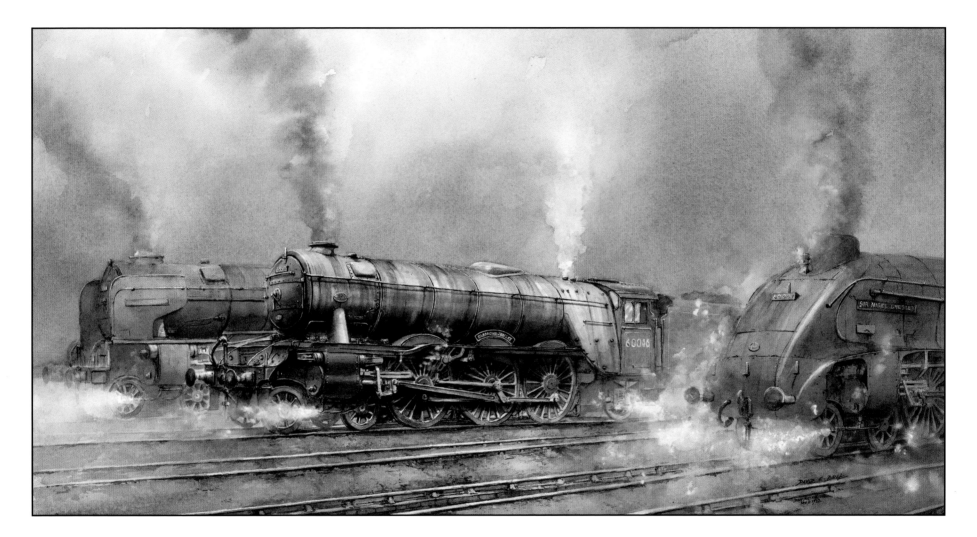

A3 'Diamond Jubilee' 60046

Doncaster Carr Loco

To the right is 60007 **Sir Nigel Gresley** and to the left is a Doncaster A1.

The plant was on the other side of the main line, further north, but after visiting the shed it was just a brisk walk over the rail bridge and into the site, usually through the paint shop window.

In its heyday, perhaps in the early Fifties, the plant would service, maintain, repair and paint more than 700 engines annually. The first engine built there was in 1867 and building continued until the final engine in 1957. Around 2,220 new engines emerged from the plant — including some of the most famous, all mentioned at some point in the book.

It was Gresley, the CME at Doncaster, who designed and built these engines — *Great Northern* in 1922 would have been one of the most famous had it not been for the trauma it suffered later. As mentioned at length earlier, the *Flying Scotsman* followed soon after in 1923.

Gresley's second masterpiece was the streamlined A4 Class with No 2509 *Silver Link*, the first of the A4s to be built in 1935. Originally it was intended that only four A4s would be built but eventually they numbered thirty-five. However, in the next batch ordered was the A4, 4468 *Mallard*. It was allocated to Doncaster on entering traffic in 1938 and while at this shed it was selected for a test run near Grantham, attaining the world speed record on 3rd July 1938.

The shed was called Carr Loco and its location plate was 36A. It was the main GNR shed with 180-plus engines at its peak and was the last steam shed operating on the Eastern region. It closed in 1966.

Frodingham, 36C, was actually my nearest shed and to see anything other than a 'dubby', J6 or an O2 was a major event, with news of such a sighting quickly spreading to the 'spotters'.

*The **Mallard** was withdrawn in April 1963. It was restored in the Eighties and last steamed in 1987. It is now preserved at the NRM York. The highly successful A4 Pacifics lasted thirty-one years before the the last two, 60019 **Bittern** and 60024 **Kingfisher**, were withdrawn in September 1966.*

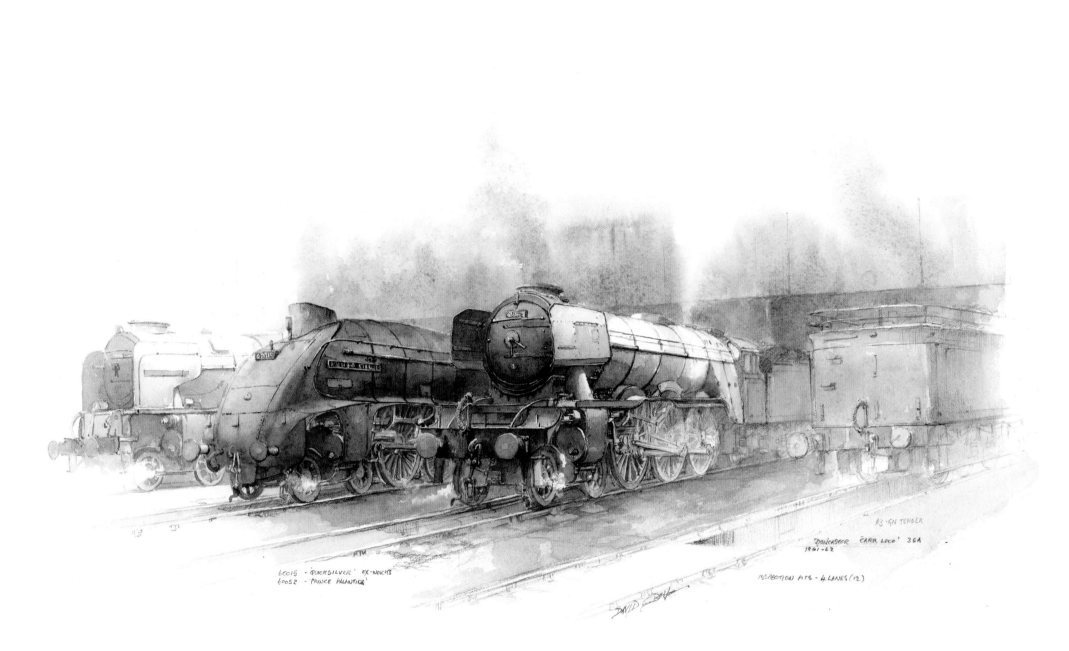

Doncaster Carr Loco c1960

A typical scene was these three types of engine — the left-hand one is an unnamed Peppercorn A1, the middle one is A4 60015 **Quicksilver***, fresh from the plant, and on the right is A3 60052* **Prince Palatine***. The date on which I'm basing the final painting is around 1960, so the A4 and A3 are visiting engines. This is the north end of the shed, though the south end aspect would look similar. The coaling tower was behind to the right and then the east coast mainline, so while 'on shed' you didn't miss seeing any traffic. The turntable was at this end, and, close by was the 'hole in the fence'. Today this area is a different world.*

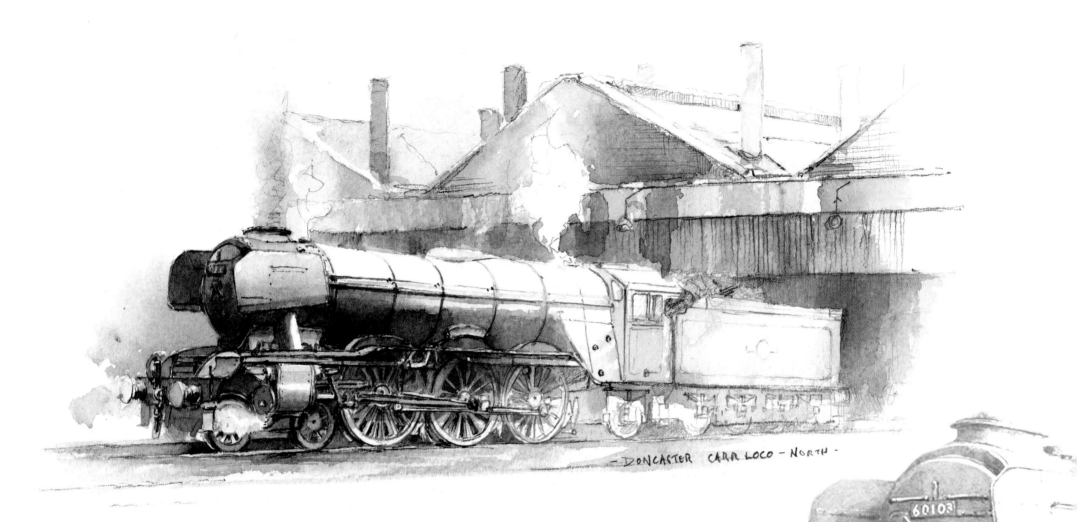

-DONCASTER CARR LOCO - NORTH -

Another scene at the shed, north end, after rebuilding. The new deflectors overcame the problems of drifting smoke created after fitting the 'Kylchap' double chimneys. With this alteration you instantly knew it was an A3.

Another common feature with which to recognise the A3 was the 'coal rails' on the tender. Some had them throughout their lives.

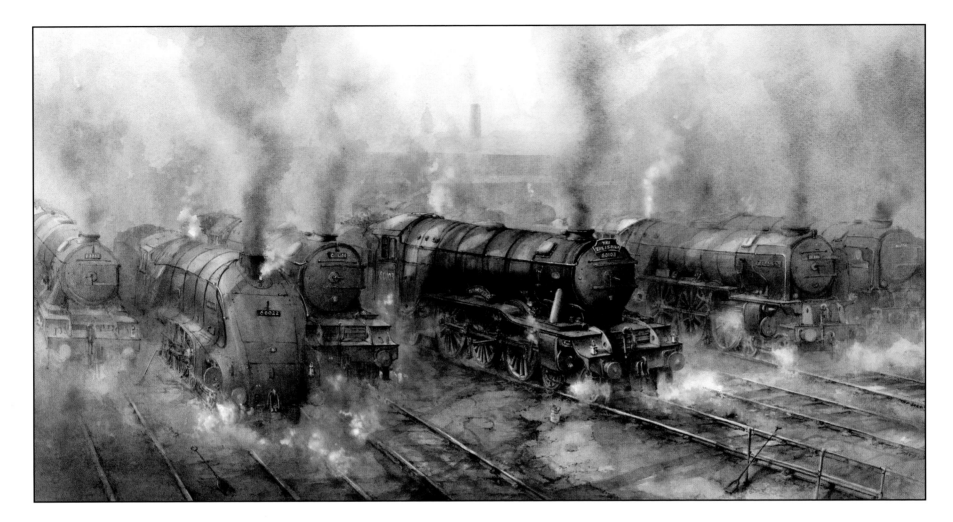

'The Gresley Gathering'

King's Cross Shed 1962

The engines from left to right are:

 ▷ A3 60062 Minoru

 ▷ A4 60022 Mallard

 ▷ A3 60066 Merry Hampton

 ▷ A3 60103 Flying Scotsman

(These are all Top Shed engines)

The two visiting engines are:

 ▷ A1 60136 Alcazar

 ▷ 60156 Great Central

(These are both Doncaster engines).

I just had to put this painting in again as it's so evocative of a great line-up of steam engines — and, of course, it's Top Shed.

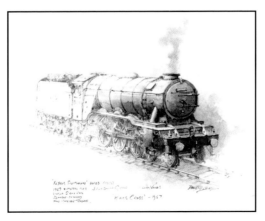

Although I now live in Lincoln, its GC shed was not one I often visited, however, because of its location it did have a fair variety of engines, including B1 and K3 classes and also visiting engines from the Midlands. The shed, which closed in 1964, was small but was not demolished and is now cleverly converted as The Engine Shed — a music venue.

Sadly, I never visited Top Shed at King's Cross, but not for the want of trying. As a young lad I knew of its existence and prestige from my days at the local railway club.

I 'steamed' into King's Cross only twice in my time departing from Doncaster, both trips behind an A1, and I cannot recall being hauled by the elusive A4. Even from the main line you couldn't see Top Shed, so in many of my works the buildings and extras are sourced from photographs, of which there are many, and applied as accurately as possible to the paintings.

King's Cross shed had, like most major sheds, in excess of 100 engines to look after. At one time nineteen A4s were based there. Apart from the first four 'Silver' A4s four famous engines were allocated to this shed — A3 60103 *Flying Scotsman*, the second A4 60022 *Mallard*, the third A4 60007 *Sir Nigel Gresley* and V2 4471 *Green Arrow*.

At Top Shed as late as 1962 you could see a great line-up of BR Pacifics and Deltics, of course. The last steam departure from King's Cross station was on 16th June 1963 and 'Top Shed' 34A closed the following day.

I've always known motor power depots as 'sheds', a sure place to find atmosphere made up from rust and grime, oil and water, usually together, and, of course, a cloud of coal dust, all the time hoping for the sighting of a 'new' engine. This is what was part of being a 'trainspotter' and has stayed with me, as most others of my generation. It is, of course, what I try to reflect in my railway work.

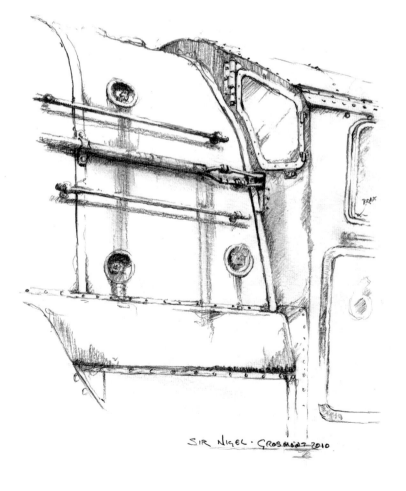

SIR NIGEL · GROSMONT 2010

60077 'THE WHITE KNIGHT'

80

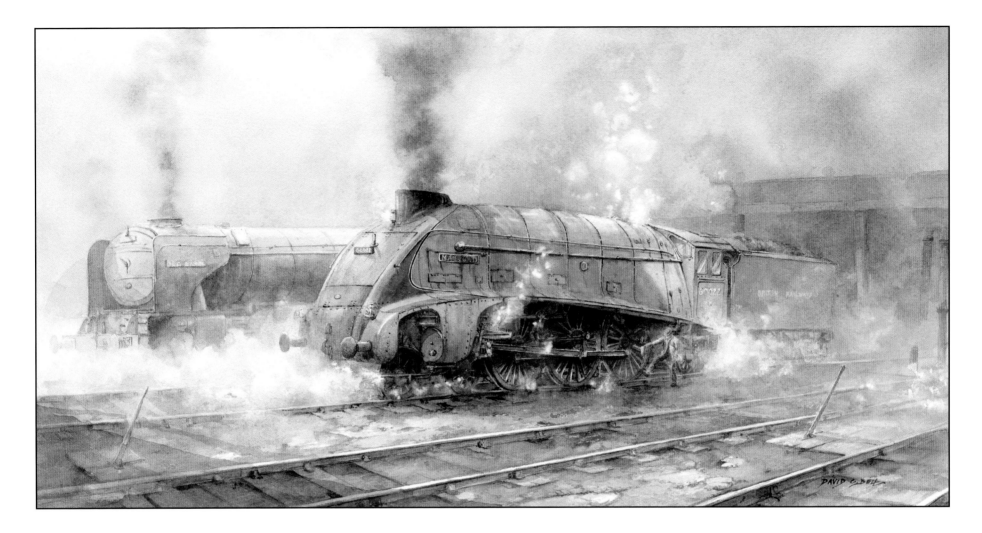

A4 'Mallard' 60022

King's Cross Shed c1949

*This is not the best reproduction of **Mallard** in the book, but I have included it to show how I first started to paint railway engines. Emphasing the profile, the power, the life and, most importantly, the atmosphere. All these works are watercolours, pencil and crayon, or a mixture, on heavy papers. I spend a lot of time in and around engines and, yes, I do sometimes make mistakes.*

In close proximity to a steam engine, the great smell is the mixture of smoke, steel and steam, although strictly speaking the steam is condensation. Anyway, it's usually hot with varying degrees of intensity and hits me every time I enter any shed, especially Grosmont.

Here the smell seems to permeate from the structure itself, as it would I suppose as the dripping and running water, the liberal amounts of oil and grease all sweating out of an engine combine with that hot, hot blast from the chimney. Even when the engine is static it's still there.

Now all the aforementioned engines are preserved in museums and railway centres in the north of England, with the *Sir Nigel Gresley* and *Flying Scotsman* still in steam.

I was not quite old enough to be a spotter in the best days of steam during the late Forties and early Fifties, probably seeing my first memorable engine aged five. Even so, I had some 17,000 engines to look forward to and hundreds of sheds and stations to visit from this time on.

My favourite of all these paintings is the large watercolour of 'The Gresley Gathering'.

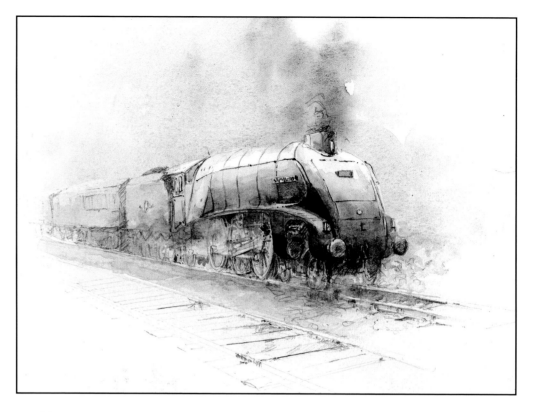

Although this sketch doesn't show an engine number, in its final version it will be **Silver Fox** *60017, which recorded the fastest speed while on ordinary duty — 113 mph with the 'Silver Jubilee' in August 1936 in the 'Jubilee' year.*

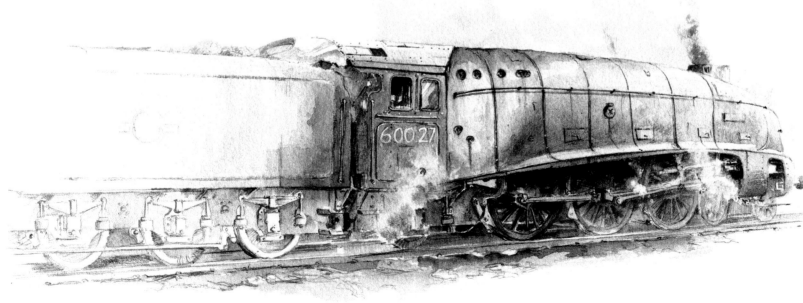

*This is not quite what it seems. I painted the **Sir Nigel Gresley** and converted it to 60027 **Merlin**, some time ago for a possible new scene. It's a method I use all the time, the snag is making sure the many variations and alterations are correct.*

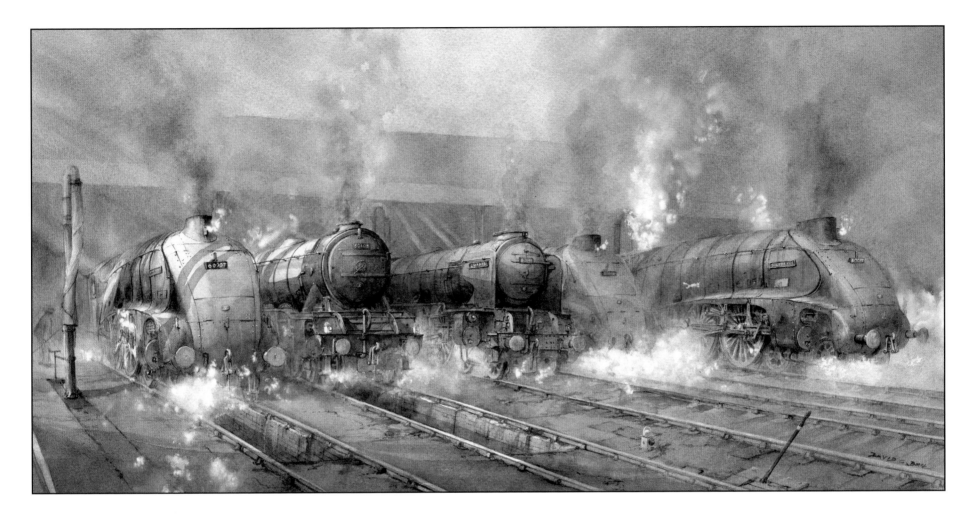

'Top Shed' King's Cross c1957

This is based around 1957 when these engines were shedded at 34A, they are from left to right:
60022 A4 **Mallard**; 60103 A3 **Flying Scotsman**; 60149 A1 **Amadis**; 60021 A4 **Wild Swan**; and, A4 and 60017 **Silver Fox**.

The hallmark of Top Shed was the condition of the engines that were turned out for their daily duties and not least of all, of course, the drivers and firemen. As always, the name Peter Townend springs to mind. The shed was established by the GN in 1850. It included the goods yard and was very cramped, so outside the station was the intermediate 'station yard' where engines could be turned and made ready. The shed itself didn't get its 70 feet turntable until 1932.

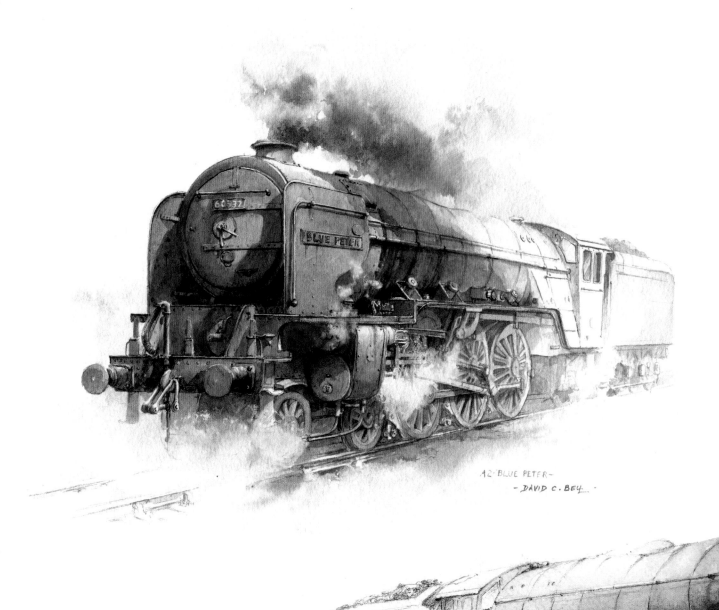

A2·BLUE PETER·
– DAVID C. BEY –

60532 Blue Peter

This sketch shows the first A2 built for BR, 60532 **Blue Peter**.

It was built at Doncaster in 1948 and fitted with a double chimney just a year later. This was a result of A H Peppercorn's improvement of his predecessor Thompson's A2/3 and included many changes. Included in these, the outside cylinders were now centred over the front bogie and the livery went from Apple green to BR green, as shown here.

This engine is preserved and in steam.

Number 60156 Great Central

When Peppercorn came to office as CME the building programme of 1946 was a mixture of his and Edward Thompson designs. His next design was a larger version and a development of his A2 class. These were the A1 class and Doncaster built the first sixteen, with Darlington producing the next twenty-three in 1947.

– GREAT CENTRAL –
A1 60156 BRITISH RAILWAYS GREEN
OCT. 1949 DONCASTER (1965)
– PEPPERCORN A1 CLASS –

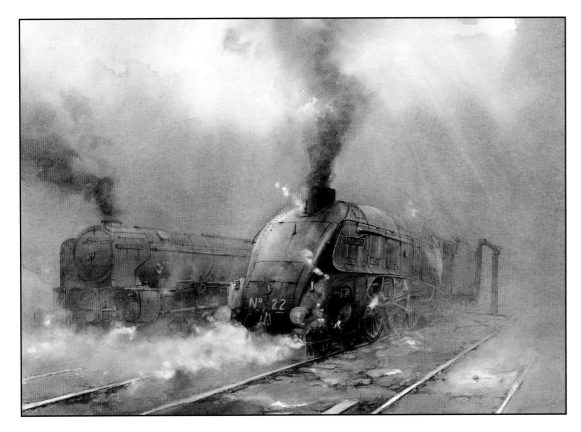

This sketch shows the LNER express livery of Garter blue. The valances were removed during the war, so this would be in that short period with this number between 1946–48 before nationalisation. Eventually, after a spell in BR blue, the final change was to BR green.

This is the famous A4 60022 **Mallard** on shed.

I finish here with one of my favourite engines, the A4 60007 **Sir Nigel Gresley.**

The engine was the 100th Pacific (4498), built at Doncaster Works in October 1937 and named after its creator. It has been in BR blue livery since 1998. It is owned by the Sir Nigel Gresley Locomotive Preservation Trust Ltd. and operated by the A4 Locomotive Society Ltd.

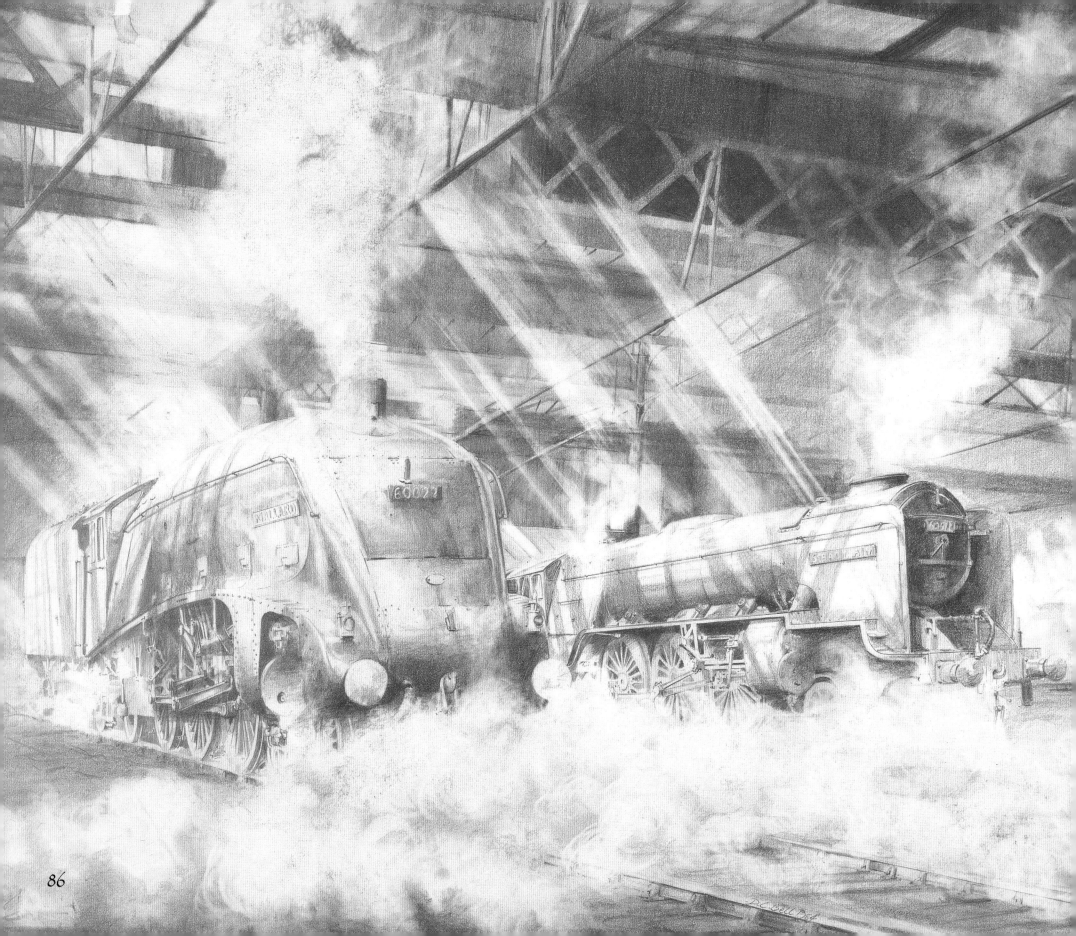

'Other Regions'
and their locomotives

As most of these drawings are created at the sheds and heritage centres I finish with a varied collection, basically, of locomotive portraits in no particular order.

When the formation of British Railways from the four major companies transpired in January 1948 it was decided to develop a 'Standard' range of engines that would be universal to all regions, that is the repair, maintenance and running would be the same anywhere on the railways. This would make the building and operating costs as 'standard' throughout the regions and the need for excessive labour, at that time a post-war shortage, to be kept to a minimum.

At the time the LMS Chief Mechanical Engineer was H.A. Ivatt, who was already improving engine maintenance and his methods were used by the new man on the block — R.A. Riddles.

Until the envisaged electrification of the railways when finances allowed it was Riddles' task to design locomotives to meet the railway requirements. The engines he designed and built would eventually total 999.

Another great place for painting is the working shed at Ropley on the Watercress Line. Here is Class 2 41312, not in steam and never moved all day.

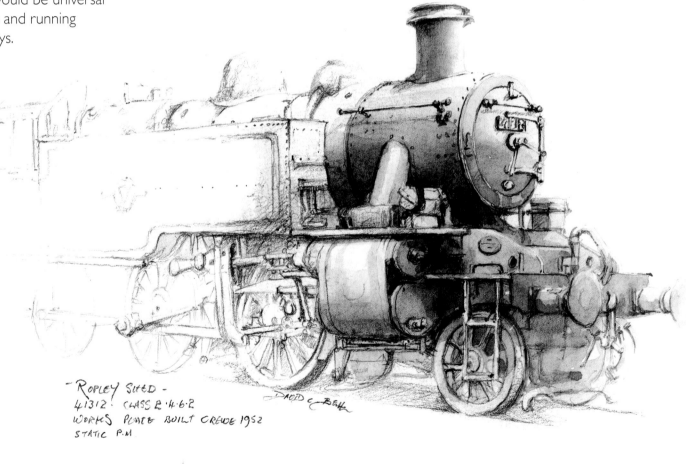

- ROPLEY SHED -
41312 · CLASS 2 · 4·6·2
WORKS PLATE BUILT CREWE 1952
STATIC P·M

DAVID C BELL

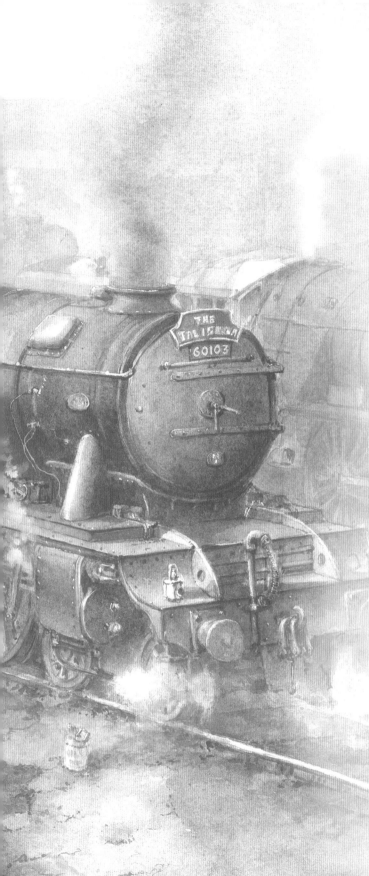

The **Papyrus** was built at Doncaster in 1929 as one of Gresley's new A3 Class of 4-6-2 Pacifics. It entered traffic in February 1929 and was allocated to King's Cross until 1937 and then Doncaster for two years. It was at Grantham during the war, and King's Cross again in 1946 until 1950, when it went to Scotland, it finally ended up at St Margarets in 1961.

I painted the **Papyrus,** not because is it an A3 but it is famous for achieving 108 mph in 1935 — the highest speed as a working non-streamlined locomotive. She was also the last A3 to work the non-stop **Flying Scotsman** in 1937.

The **Papyrus** was based at King's Cross at the time and was chosen to run the high-speed test run to Newcastle and back. It was on the return on the downhill section of Stoke Bank when she achieved the record speed. It should have been a good enough reason to be selected for preservation but it was not to be. **Papyrus** was withdrawn because of a cracked frame and cut up in 1963.

In the painting the engine is shown in Apple green livery, which it had between 1947 and August 1949, until it was painted in the experimental livery of blue, as is the A1 behind on the left, the next month at Doncaster works. It also has a GN tender with the familiar coal rails. My research shows the engine back with a 1922 GNR tender and not the corridor-tender it had when on the non-stop run in the Thirties. I've chosen the date as summer 1949 and on a north bound run from York.

When it was allocated to Scotland in 1950 it rarely went south of the border. The engine behind is a new A1 and I have based it on 60128, which was built at Doncaster and entered traffic in May 1949 in the new blue livery. It was named **Bongrace** in November 1950.

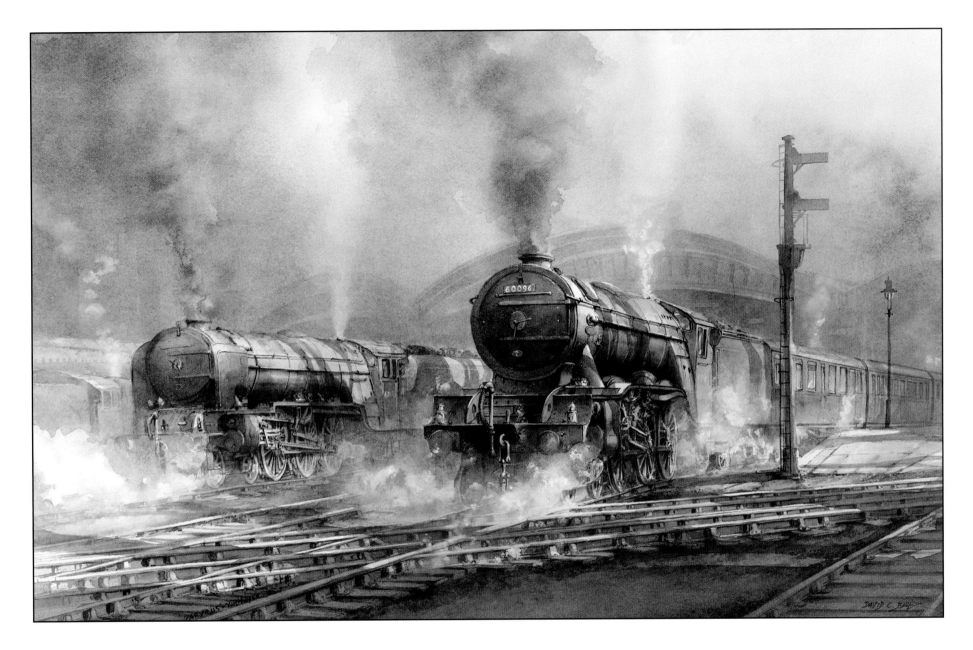

60096 Papyrus A3

York Station c1949

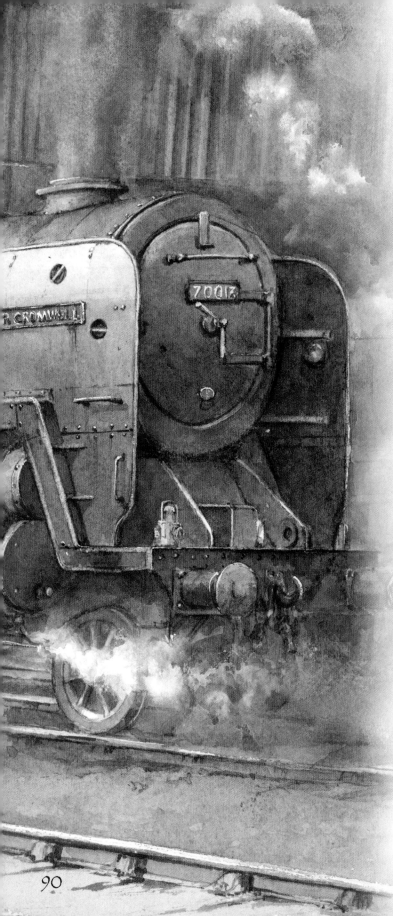

The 'trials' of 1948, when locomotives were exchanged throughout the four regions, confirmed it was time to design new locomotives, or modify, existing ones. This resulted in four new classes, the Britannia Class 7, 9F Class, Class 5 and Class 4. There were another four classes based on existing locomotives and a further four on existing locomotives with minor alterations. Altogether twelve designs were built to fill the gap before diesel/electrification. Oddly enough, some existing designs continued to be built such as the A1 Pacifics (LNER) and the endless Class 5, or 'Black Fives' as they were known. A total of 1,538 locomotives were built.

The first was the Britannia Class 7 and two of the Britannias 70000 and 70013, are now icons in the steam world.

The Britannias featured many improvements, even some of the weight-saving methods from Bulleid's Light Pacifics. They had a narrower and stronger frame, and smaller six feet two inch driving wheels. The most significant modification was just the two cylinders, omitting the third central cylinder that was previously standard for all Pacifics and this helped enormously in the difficult maintenance of this component. The other notable change was the much higher running plate from cab to cylinder, which gave clear and easy access to wheels and motion. This was a feature on all the Standards.

Of note, the firebox was fitted with a 'rocking' grate and ash-pan with doors underneath. This was so the firebox ash and clinker could be 'rattled' and fall into the ashpan — even while the engine was in motion.

The chimney on the Britannias was perfectly placed in the centre of the smokebox, but was only of the Swindon 'single' type.

Yet another feature was the positioning of the regulator, which now went outside the boiler, on the left side with a two-rod movement, to the rear of the smokebox and into an arched access box on the top.

All fifty-five engines were built at Crewe works, in three batches — starting in 1951 and finishing in 1953. As railway aficionados will know, they were not 'identical' and having been built over three years they had many small variations.

Livery 'lining' was another hit and miss affair. The classic orange and black lining was not always the case as they sometimes had a double red line at either end, but again sometimes neither.

My featured engine, *Oliver Cromwell* was, as a preserved locomotive, the last BR engine to be overhauled and also hauled the last steam train on BR.

My familiarity with the Brits was seeing the six o'clock fish-train from Grimsby, to, I always assumed London, every weekday evening as it flew down the exposed gradient to Keadby. I believe there were five Brits located at Immingham for this service — 70039, 70035, 70036, 70038 — and I just cannot remember the fifth? I have never seen a photograph of this regular run fish-train.

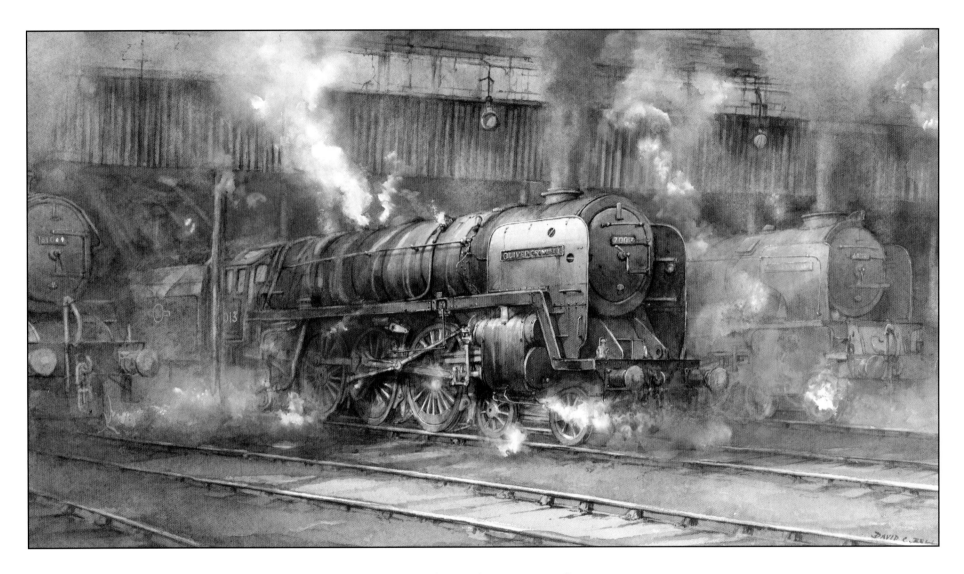

Britannia Class Oliver Cromwell 70013

Carr Loco Doncaster September 1959

*The Britannia Class 7 Pacific was the first of Riddle's Standard Class engines built for British Railways. The fifty-five of this class were built between 1951 to 1954 and this engine is now preserved, the other being the first built, No 70000 **Britannia**. This class would almost always be seen on all major sheds and in all regions.*

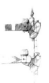

The whole point of the new Standards was that they should be an improvement on the existing engines. As with all the new Standards, the proposed Class 8P design was to bring together the latest possible innovations and up-to-date technology to produce an engine that could match the Stanier Pacifics. However, with the destruction of the Stanier Pacific *Princess Anne* in an accident in 1952, the opportunity was taken to build a prototype.

I have a great passion for steam engines, far more than my actual knowledge, but this engine needs a little explaining.

The proposed engine, to be named *Duke of Gloucester*, was to be a bigger Britannia Class engine, still with the two cylinders. Alas, this was not possible as the size of the two cylinders would exceed the national loading gauge and so to remedy this a third cylinder was introduced. The major change was to switch to the Italian–British-designed Caprotti valve gear, which needed well-designed steam control and the fitting of a Kylchap blastpipe. Unfortunately it wasn't fitted, having a standard double chimney instead, and this could not cope with the fierce Caprotti exhaust. This resulted in an inferior locomotive, being a poor steamer and excessive in coal consumption. Its design should have given it great acclaim but the combustion of coal and therefore the whole cycle of steam power was inhibited. Thus it never got past the prototype stage.

After an initial showing at the International Railway Congress at Willesden shed in 1954, it entered traffic at Crewe in 1954 and for the next eight years of its life the engine was used for minor duties until withdrawn in 1962.

As it was a one-off design, parts of it were scheduled for preservation and one cylinder and the valve gear were removed and sent to the Science Museum. The rest of the engine was sent for scrap at Woodhams in Barry. Astonishingly it was saved and purchased for preservation in 1974 by the Duke of Gloucester Steam Locomotive Trust. After twelve years of work, which included the fitting of a Kylchap blastpipe and other modifications, it is now a first-class restored engine and runs on the mainline.

There was an interesting article by Alan Baker on the performances of Stanier Pacifics compared to the *Duke*. The coal, or the burning of coal was the key to performance. It would follow that the, not quite failure, but disappointment on its expected potential gave the *Duke* a negative image.

The first of Riddles' designs was the Britannia Class for mixed traffic (MT). Known as Brits they were a minor classic among the Pacifics already running,

This drawing is of the proposed bigger Class 8 Pacific **Duke of Gloucester.** Now preserved, it was the only one of its class. Sketched whilst visiting York museum.

71000 - 'DUKE OF GLOUCESTER'
N.R.M. YORK

DAVID C BELL

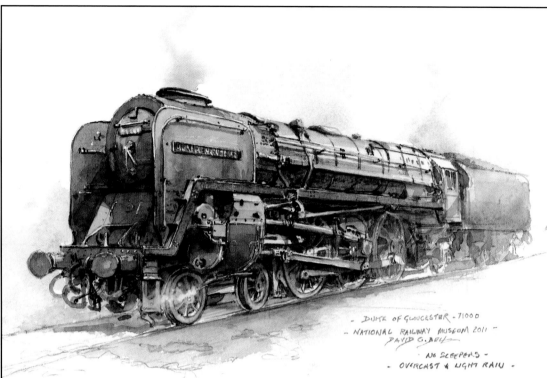

- DUKE OF GLOUCESTER - 71000
- NATIONAL RAILWAY MUSEUM 2011 -
 DAVID G. BELL
 - NO SLEEPERS -
 - OVERCAST & LIGHT RAIN -

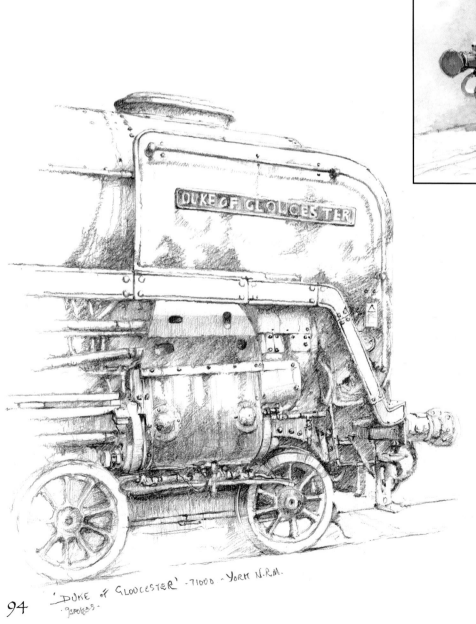

'DUKE OF GLOUCESTER' - 71000 - YORK N.R.M.
- 9 SPOKES -

I drew both these at the NRM and mentioned the engine in Chapter One but I have included them here, as a comparison, with the Britannias.

This Pacific was one of the post-nationalisation Standards — the Class 8 Pacific. Its design was to bring the latest possible innovations and design technology to produce an engine that could match the Stanier Pacifics.

GWR 7800 Class 7 Foxcote Manor 4-6-0

This engine, 7822, was designed by Charles Collett in 1938 and was built at Swindon Works in 1950. Seen as an average type of mixed traffic engine it was actually an economically designed, if not devised, locomotive from other engine parts and became the 78XX Manor Class. The light axle load made the engine suitable for the lighter lines of the GWR and twenty were built. Not the greatest engine by all accounts but after the war another ten were built, this time with some crucial improvements that made it into a first-class engine. Of the thirty built a staggering nine have been saved for preservation. I first saw it at the NYMR and immediately took to it with pencil and paper. It is the smallest of the GWR's 4-6-0s. The drawing inside the cab is highly detailed to show the wonderful workmanship of the Swindon engineers. The regulator handle is a work of art in itself and most parts, especially those made of brass, have the engine's name or number stamped on.

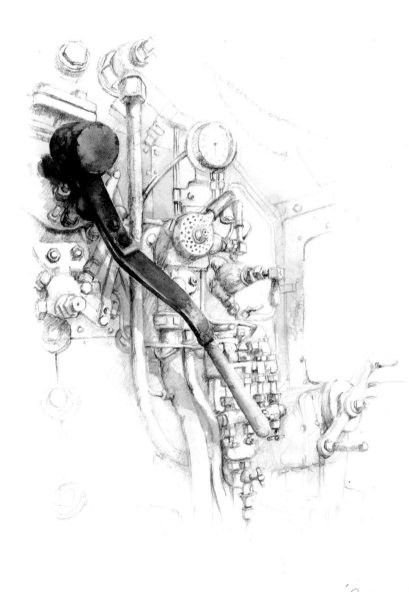

The cab of *Foxcote Manor*, a visiting engine at Grosmont shed and at the time still in steam.

95

West Country Class 'Boscastle' 34039

Oliver Vaughan Snell Bulleid was born in New Zealand to immigrant parents but the family moved back to Wales after the death of his father when he was aged seven. After college and at the age of eighteen he joined the Great Northern Railway at Doncaster as an apprentice under the great CME — H.A. Ivatt. I liken Bulleid to the great sailor Cook, who had a talent for mathematics at an early age. Bulleid obviously had this considerable gift as he was manager at Doncaster Works within five years and destined to become a renowned engineer. He worked abroad and at the Board of Trade and it was at this time he met and travelled with the engineers Gresley, Stanier and Hawksworth and saw developments in steam engines. He then moved back to the GNR as assistant to the CME, Nigel Gresley.

After the war, Bulleid left the Army and went back to the GNR as Manager of the Wagon & Carriage Works. After the grouping of 1923, Gresley became CME of the LNER and recruited Bulleid as his assistant. It was this experience with Gresley and his famous locomotives that enabled him to be selected, after the retirement of Maunsell, as the CME of the Southern Railways in 1937 until retiring in 1948.

We now come to his proposed Merchant Navy Class of 1941, which was to be a 'modern' 4-6-2 Pacific. The engines were designed and built with many new innovations.

The odd but express-looking streamlined casing, or correctly termed 'air-smoothed casing', the high boiler pressure 280 lb/sq in, the distinctive 'Bulleid Firth Brown Wheels' (the American Boxpox wheels with 'holes' in) and his chain driven valve gear, enclosed in an 'oil-bath' were just some of his modifications.

The first engine was 21C1 *Channel Packet* (35001), which entered traffic in 1941. It was a very successful steam engine but a major flaw turned out to be the enclosed chained gear in an oil-bath. To solve this problem the whole class was rebuilt with Walschaerts valve gear and the streamlined casing removed between 1957–59. This is how the preserved engines are today and the similarity to the Britannia Pacifics can be seen. The rebuilt engines performed well until the last days of steam on Southern rails and an amazing eleven engines have been preserved, although none in the original form.

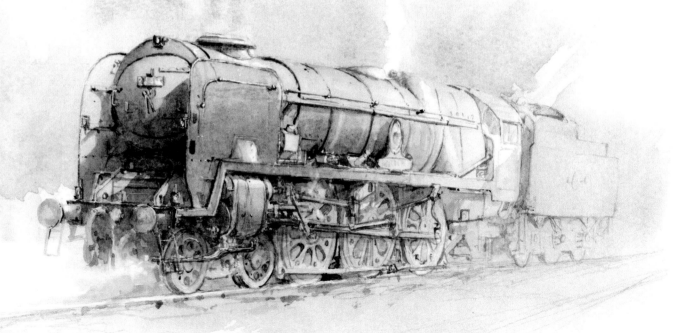

Battle of Britain Class 7P 34088 '213 Squadron'

The newly introduced Lemaître blastpipe arrangement gave the engine a very distinctive sound when in steam.

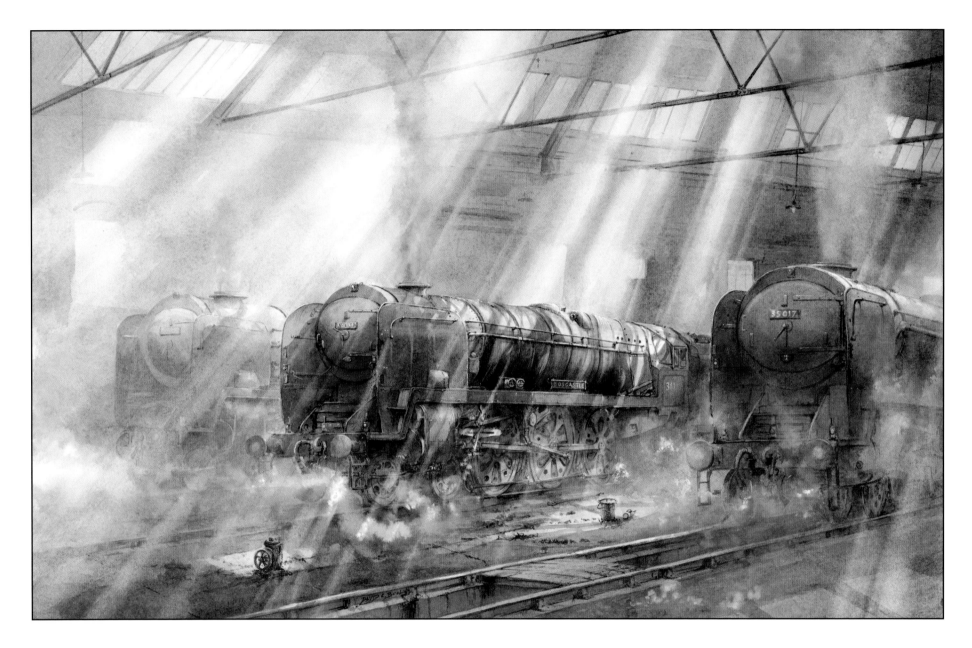

West Country Class Boscastle 34039

Eastleigh Shed c1962

Eastleigh Shed (71A) was a long, open-ended shed with ten lanes and was situated next to Eastleigh Works. Any visitor would more than likely see an engine as 'new' when released from the works on to the shed

Though not Eastleigh-based, the engine on the right is the rebuilt Merchant Navy Class 35017 **Belgian Marine**.

Next was the need to design a new mixed traffic but lighter locomotive for the demanding routes of the Southern and West Country tracks.

Construction started in 1945 of what was to become the West Country and Battle of Britain classes, and, though very similar, it was a slightly smaller and lighter engine than the previous Merchant Navy Class. The first of 110 engines was 21C101 *Exeter*, which was built at Brighton Works and entered traffic in July 1945. The colour was the distinctive Southern region Malachite green. These light Pacifics had the new and first-time technology of welding in their construction, which was brought about by the wartime need for speed and economy. Again, after problems with the Bulleid chain-driven valve gear, sixty engines were rebuilt under British Railways.

Bulleid had maintained that the casing was in fact built to allow easier cleaning and maintenance of the locomotive but it was all removed during the late Fifties. By 1951 the class had increased to 110 and that included forty built under British Railways. Unfortunately I haven't been able to include many paintings of this class here. The rebuilding programme came to an end in 1961 when just over half had been modified and by 1963 they were being withdrawn. The fact that many Southern Region and Great Western engines were to be disposed of at Woodhams scrapyard in Barry, South Wales, where claiming and purchasing an engine was possible, is the reason so many have been saved for preservation. Twenty engines have been restored or are waiting for restoration.

The West Country Class *Boscastle* entered traffic in September 1946 as No 21C139, and later in 1948 renumbered 34039. It was first allocated to Stewart's Lane (73A) in Battersea, then Brighton and eventually Eastleigh Shed (71A) in 1962. This is where I've based the painting.

The engine was rebuilt in 1959, withdrawn at Eastleigh in May 1965 and is currently preserved on the Great Central Railway.

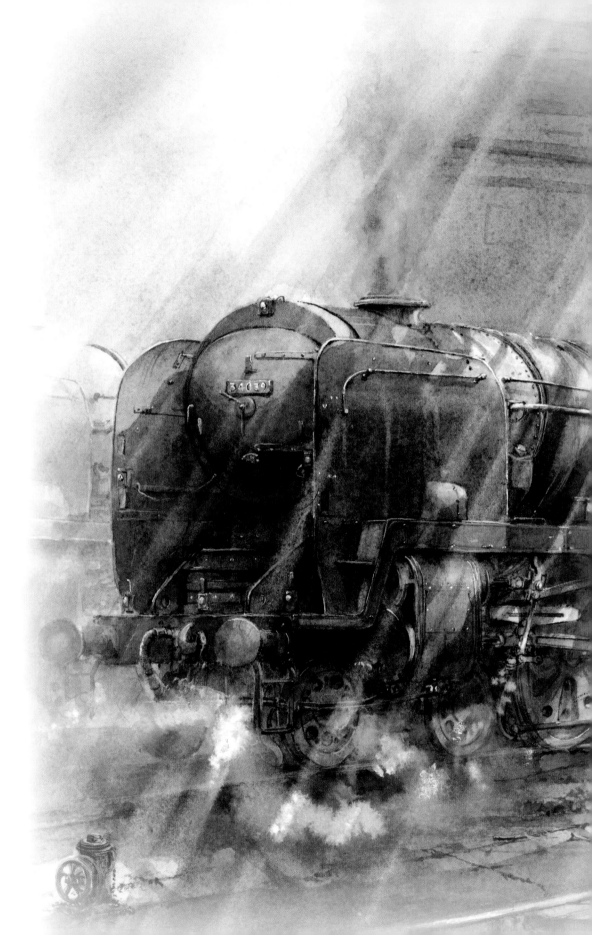

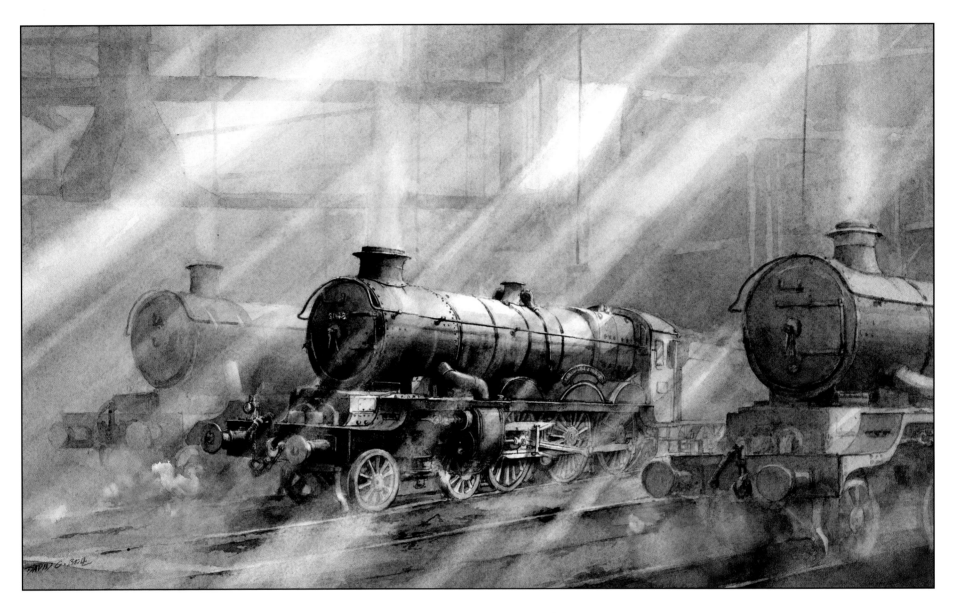

'Earl of Mount Edgecumbe'

GWR 4073 Class No 5073 — On Shed

A GWR Castle Class engine built in 1936, originally called **Barbury Castle** but renamed in 1937.

This engine was withdrawn in 1963, retrieved from Barry scrapyard in 1973 by the Birmingham Railway Museum and restoration started in 1996. After considerable rebuilding the engine was in steam by 2008 and is now fully restored and running on the mainline. This watercolour painting, for a possible shed scene, is the last stage in composition before a final rendition. The next step will, eventually, be a painting of a similar scene and based on one of the turntables at Old Oak Common or Tyseley sheds in the Fifties.

I finish with several preparation drawings for proposed paintings of GWR engine shed scenes.

I normally only draw preserved engines from life or studio-finished from photographs and make the necessary changes if a different engine is needed.

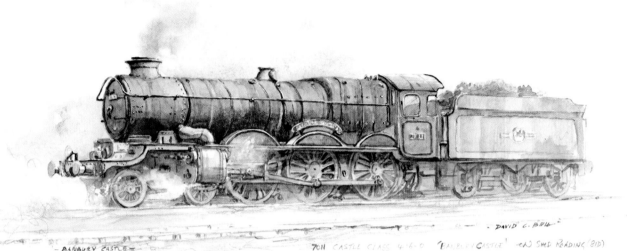

- BANBURY CASTLE -

7011 CASTLE CLASS 4-6-0 'BANBURY CASTLE' *AS SHED READING (81D)
GWR C.COLLETT DESIGNED 4 CYLINDER 4-60 - 160 BUILT - WITHDRAWN 1965
- SHOWN 'BRUNSWICK GREEN' - PROBABLY THE BEST COLOUR FOR GWR ENGINES
ORANGE/BLACK LINING - BRASS EDGING FRONT & BACK ON CAB

- DAVID C. BELL -

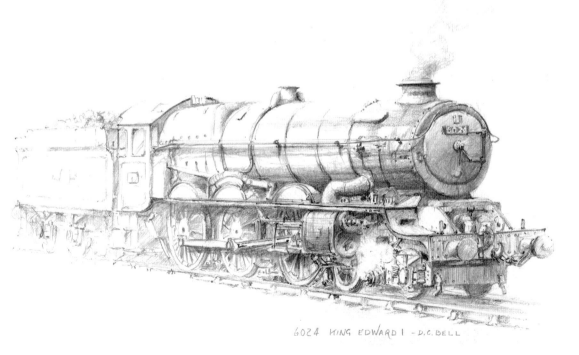

6024 KING EDWARD I - D.C. BELL

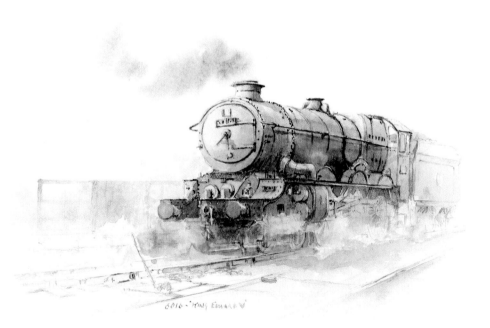

6010 "KING EDWARD V"

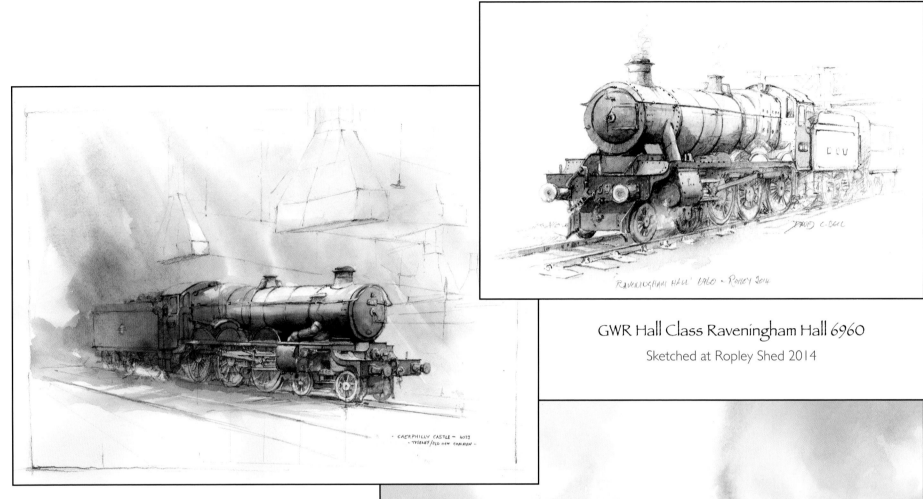

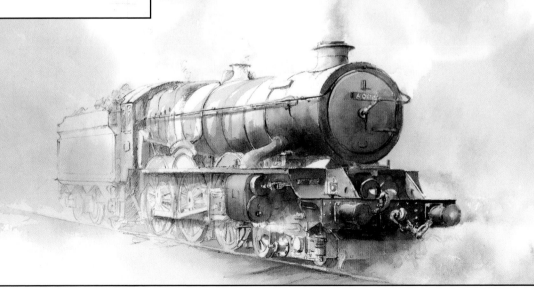

GWR Hall Class Raveningham Hall 6960

Sketched at Ropley Shed 2014

*The painting above, the first of its class, is **Caerphilly Castle** No 4073. A contrived watercolour, it is the last stage before a final rendition. The sketch on the right is a King Class engine.*

Bibliography

British Steam Engines	—	O.S. Nock
The Book of A3 Pacifics	—	P. Coster
Great Days of the Southern Railway	—	P. Whitehouse
British Steam	—	P. Whitehouse
Railway Liveries	—	B. Haresnape
Steam on the Shed	—	P. Whitehouse
Ninety Years On	—	P. Coster
The Southern Remembered	—	J. Whitely & G. Morrison
Profile of the A4s	—	J. Whitely & G. Morrison
Steam into Wessex	—	M. Esau
West Country & Battle of Britain Pacifics	—	R. Derry
Steam Sheds	—	C Gammell
More Southern Steam on Shed	—	Fairclough & Wills
BR Standard Pacifics	—	P. Swinger
The Power of the Merchant Navies	—	G. Morrison
LNER Locomotives A1 & A3	—	W. Yeadon
The Book of the A1 & A2 Pacifics	—	P. Coster
The Power of the A2s	—	G. Morrison
The Book of 9Fs	—	R. Derry
The Book of the A1s, A2s & A3s	—	J. Whitely & G. Morrison
The Power of the 9Fs	—	G. Morrison
Top Shed	—	P. Townend
Duchess of Sutherland	—	J. Radford & B Ewart
Locomotives in Detail — Standards	—	D. Clarke
North Yorkshire Moors Railway	—	P. Benham
LNER Sheds in Camera	—	J. Hooper
A History of the LNER	—	M. Bonavia
The Book of the Coronation Pacifics	—	I. Sixsmith
Flying Scotsman	—	B. Sharpe
The Book of BR Standards 1 & 2	—	R. Derry
British Locomotive Classes	—	Ian Allan
From the Footplate	—	O.S. Nock
GWR Sheds in Camera	—	R. Griffiths
National Railway Museum	—	York